LIFE
The Year in Pictures

LIFE
The
Year
in
Pictures

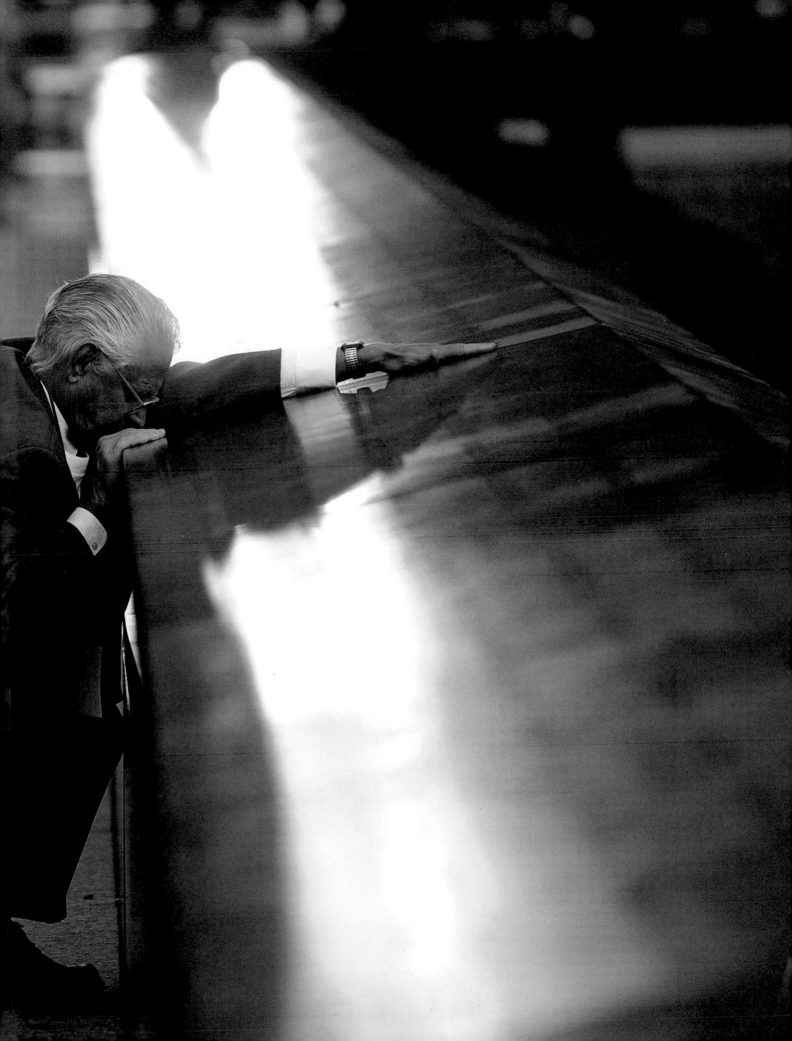

LIFE Books
Managing Editor Robert Sullivan
Director of Photography Barbara Baker Burrows
Creative Director Mimi Park
Deputy Picture Editor Christina Lieberman
Copy Editors Barbara Gogan (Chief), Parlan McGaw
Writer-Reporter Marilyn Fu
Photo Assistant Sarah Cates
Reporter Michelle DuPré
Consulting Picture Editors
Mimi Murphy (Rome), Tala Skari (Paris)

Editorial Operations Richard K. Prue (Director),
Brian Fellows (Manager), Keith Aurelio, Charlotte Coco,
Tracey Eure, Kevin Hart, Mert Kerimoglu, Rosalie Khan,
Patricia Koh, Marco Lau, Brian Mai, Po Fung Ng,
Rudi Papiri, Robert Pizaro, Barry Pribula, Clara Renauro,
Katy Saunders, Hia Tan, Vaune Trachtman

TIME HOME ENTERTAINMENT
Publisher Richard Fraiman
Vice President, Business Development & Strategy
Steven Sandonato
Executive Director, Marketing Services Carol Pittard
Executive Director, Retail & Special Sales Tom Mifsud
Executive Director, New Product Development
Peter Harper
Director Bookazine Development & Marketing
Laura Adam
Publishing Director Joy Butts
Finance Director Glenn Buonocore
Assistant General Counsel Helen Wan
Assistant Director, Special Sales Ilene Schreider
Book Production Manager Suzanne Janso
Design & Prepress Manager Anne-Michelle Gallero
Brand Manager Roshni Patel
Associate Prepress Manager Alex Voznesenskiy

Editorial Director Stephen Koepp

Special thanks to Christine Austin, Jeremy Biloon,
Jim Childs, Susan Chodakiewicz, Rose Cirrincione,
Jacqueline Fitzgerald, Carrie Hertan, Christine Font,
Jenna Goldberg, Lauren Hall, Hillary Hirsch, Mona Li,
Amy Mangus, Robert Marasco, Kimberly Marshall,
Amy Migliaccio, Nina Mistry, Dave Rozzelle,
Adriana Tierno, Vanessa Wu

ISBN 13: 978-1-60320-214-5
ISBN 10: 1-60320-214-5
Library of Congress Control Number: 2011940344

Vol. 11, No. 17 • December 9, 2011

"LIFE" is a registered trademark of Time Inc.

We welcome your comments and suggestions about LIFE
Books. Please write to us at:
LIFE Books
Attention: Book Editors
PO Box 11016
Des Moines, IA 50336-1016

If you would like to order any of our hardcover
Collector's Edition books, please call us at:
1-800-327-6388 (Monday to Friday, 7 a.m.–8 p.m.
or Saturday, 7 a.m.–6 p.m. Central Time).

Page 1: On April 29 in London, Prince William of Wales
escorts his bride, Catherine, Duchess of Cambridge,
from the 1902 State Landau as they arrive at Buckingham
Palace for a very well received public kiss on the balcony,
which is followed by a bang-up wedding reception.
PA/ABACAUSA/POLARIS

Pages 2–3: Robert Peraza, who precisely 10 years earlier
lost his son Robert David Peraza, a 30-year-old bond trader
at Cantor Fitzgerald, pauses after reading his boy's name
at the North Pool of the 9/11 Memorial during anniversary
ceremonies in New York City. JUSTIN LANE/GETTY

These pages: The Space Shuttle *Atlantis,* photographed by
the Expedition 28 crew of the International Space Station, is
on its way home on July 21. When it and its four-member crew
land at the Kennedy Space Center in Florida, the 30-year-old
Space Shuttle Program comes to a close. NASA/REUTERS

CONTENTS

INTRODUCTION

Who Would Have Thought?

Every year has highs and lows, big events and a multitude of smaller ones. Two thousand and eleven was not different, and yet it was: The highs seemed higher, the lows lower, and the bigs bigger. The absurdities seemed more absurd than usual, and the calamities seemed more calamitous.

Consider: Mubarak was booted out and put on trial, and bin Laden and Gadhafi were killed. Europe practically went broke (and might yet), while U.S. markets went on a roller-coaster ride out of Six Flags—daily swings (more often plummets) regularly registering in triple digits. New, leaderless movements in the United States were suddenly more popular (and way more populist) than the two established political parties. Violent rampages in places such as Arizona and Norway stunned everyone awake and made us ask: What is happening? The Internet and all things electronic continued their relentless push into daily life, raising issues of privacy, connectivity, cyberbullying, and whether or not there was any further need for the U.S. postal service.

Earthquakes, truly big ones, hit in every quadrant of the globe, literally knocking the earth off its axis. Japan was overwhelmed by tsunamis. Devastating rains and floods claimed thousands of buildings and lives in places as unrelated as Thailand and the American Midwest. The end of the world was announced . . . and rescheduled. A woman known as Lady Gaga became the biggest celebrity of all. LeBron James, having cunningly stacked the deck, again did not win the NBA championship. He may never.

What is the world coming to?

It's a question all of us asked this past year. It truly was a time when some of us wondered, "Is the apocalypse upon us?" Records were set on a monthly basis: poverty,

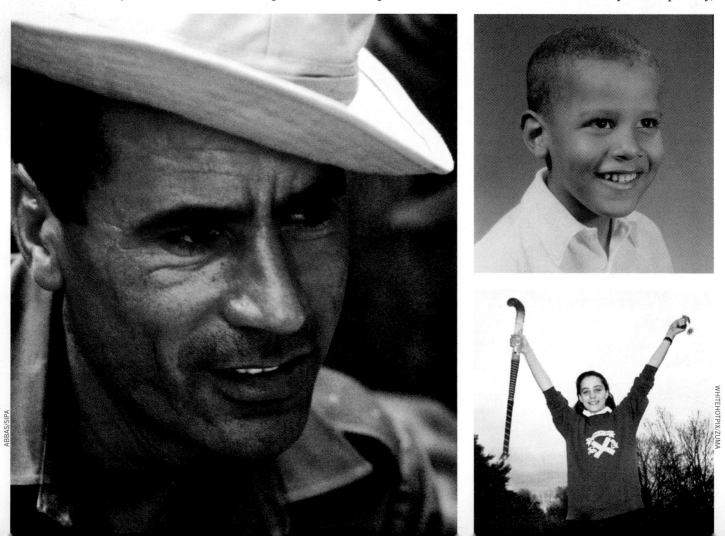

ABBAS/SIPA

WHITEHOTPIX/ZUMA

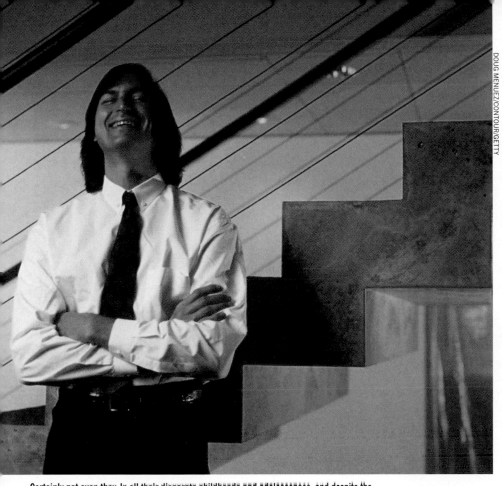

Certainly not even they, in all their disparate childhoods and adolescences, and despite the fact that many of them shared an ambition to be world-beaters, could ever have dreamed that fate would bring them together to define a crazy, crazy year. Opposite, clockwise from far left: Muammar Gadhafi in Algeria, 1973; "Barry" Obama in Hawaii in the 1960s; Kate Middleton as an English schoolgirl field hockey star in the 1990s. This page, clockwise from above: Steve Jobs in Redwood City, California, 1988; Stefani Germanotta (known to you as Lady Gaga) on the day of her first communion in New York City, circa 1994; Amanda Knox as a soccer player in Seattle in the early 1990s; and Osama bin Laden in Sweden at age 16.

unemployment, tornadoes, distrust in government, hurricane damage in Vermont, of all places. What, if anything, made any sense?

And then there were the rays of sunshine, the too brief moments of relief. The yearlong Arab Spring had its tensions, but also its several triumphs. When Prince William and Kate Middleton married, oh so splendidly, we all smiled. And also, somehow, when Elizabeth Taylor passed away, it was with warmth rather than sadness that we marked her passage. As we reminisced and looked at the old picture of lovely Elizabeth, we were taken back to a glamorous age that seemed a hundred years ago. But it wasn't. It was, really, only yesterday.

Consider the people who marked this extraordinary, tumultuous year. How could anyone have ever considered, even remotely, that the deaths of Liz Taylor and Steve Jobs—an icon of bygone Hollywood, the last Movie Star; and the man of today and the future—would be signal events within months of one another? That the big international news would involve such as Muammar Gadhafi, a once-charismatic leader turned ruthless despot, and Kate Middleton, a British commoner marrying into the royal family? That our first black President, of whom we might be proud even if we don't agree with him, would find himself embroiled in a ridiculous debate about where he was born? That a scion of a fabulously wealthy Saudi family who had turned into the world's Most Wanted terrorist would finally be found and killed in Pakistan—so far from his roots, and perhaps harbored by America's "allies"?

Not even these people themselves might have ever imagined, when they were younger, that somehow all of this *stuff*—all that they represented, all that they did, the lives that they led—would come together to define an altogether strange year early in the 21st century. They, and our natural world itself—with all of its recent quaking and shaking and storming and blowing—seemed to be saying on a weekly basis: Hang on. This is a rocky ride we're on.

It was indeed a rocky ride in 2011, as the pages that follow illustrate. It was also a year that featured romance, uncommon bravery and at least a modicum of fun. Two thousand and eleven was surely a year worth remembering, and we do so in this volume.

And after we do, we ask: Who in the world knows what 2012 will bring, and who might it bring to the fore?

Winter

Well, Actually, Summer

It was the warmer season Down Under when, on February 22, a magnitude 6.3 earthquake hit the New Zealand city of Christchurch on the South Island. This was an aftershock of a 7.1 temblor that had rocked the island only the previous September. That quake claimed no lives, but this one took 181, making it New Zealand's deadliest earthquake in 80 years. It was followed by yet another aftershock on June 13 in the so-called Christchurch swarm—this one a 6.3—but all of these would be dwarfed in this Earthquake Year by news from Japan, which is related later on page 16 of this chapter. In this photograph, Mark Bascand of Glacier Explorers shows passengers one of the many icebergs that calved off Tasman Glacier into Tasman Lake as a result of the February quake.

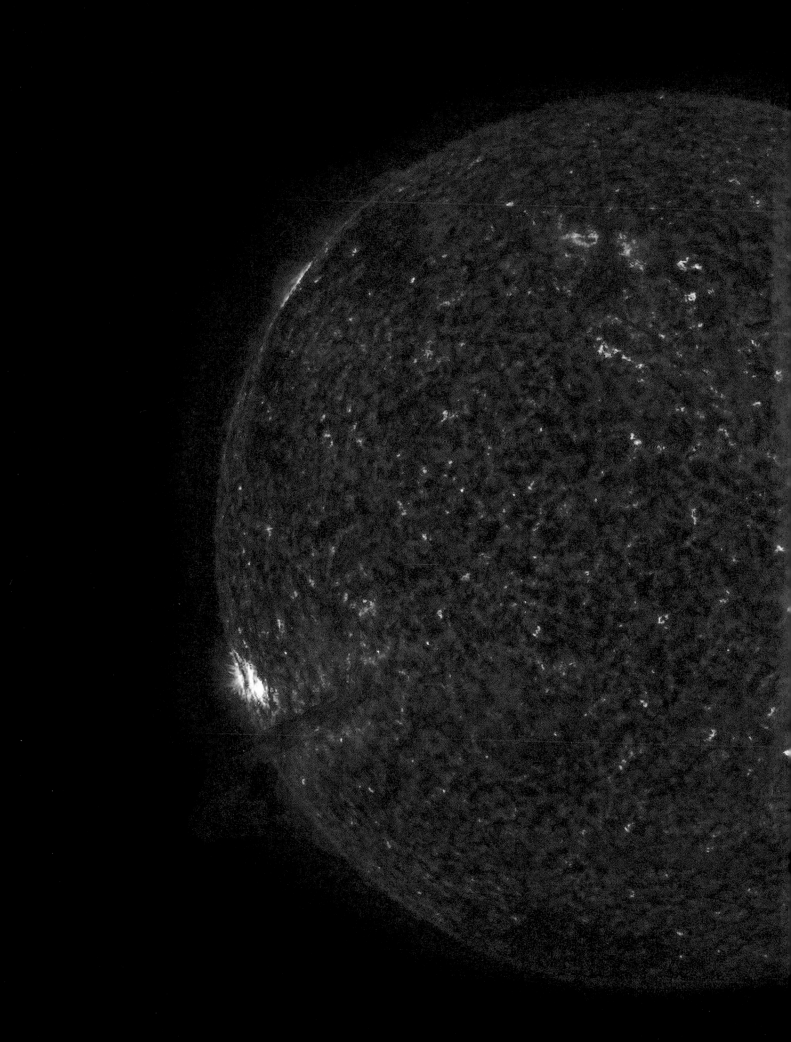

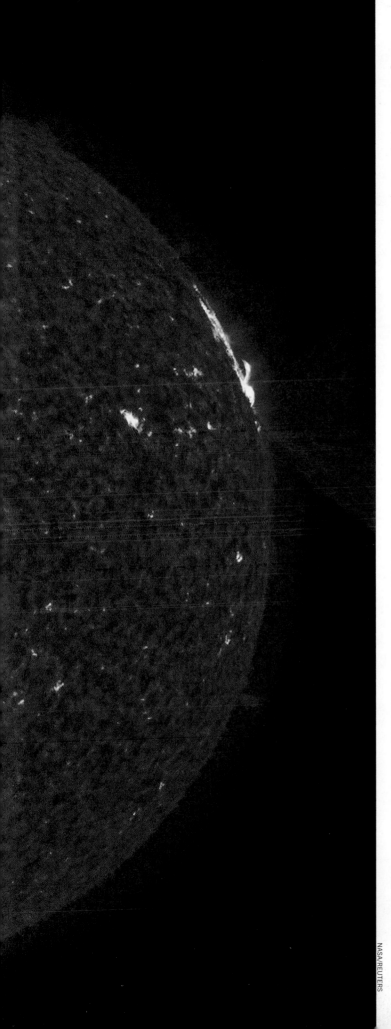

Hot Stuff

This image of the sun, captured by NASA's Solar Dynamics Observatory spacecraft on January 28, 2011, shows nearly simultaneous solar eruptions on opposite sides of the sun—a rare double whammy. A filament on the left side of the picture has become unstable and erupts, while an M-1 flare and a coronal mass ejection on the right blasts into space. An M-1 class flare is a medium-size event that can cause, say, brief radio blackouts on earth—but our planet weathered January's solar storms with little consequence. It is predicted that 2013 will be a time of heightened solar activity. Whether this will result in a blip in the broadcast, burnt-out electrical wires, nothing at all or the end of the world is being discussed online.

January 2 Canadian Kathryn Gray, aged 10, becomes the youngest person to discover a supernova, while studying images that had been sent to her father, an amateur astronomer. **Supernova 2010lt** is 240 million light years away in the galaxy UGC 3378, in the constellation of Camelopardalis.

January 9 South Sudanese vote in a historic referendum that will decide whether the Christian- and animist-dominated southern region will secede from the Arab-dominated northern region of Sudan. After 99 percent vote in favor of the split, **the Republic of South Sudan** is on the way to becoming an independent state, a status that will be affirmed six months later (please see page 62).

January 10 Tom DeLay, the former Republican United States House of Representatives Majority Leader, is convicted of money laundering for Texas legislative candidates. The 63-year-old DeLay, who from 2002 to 2005 was the third most powerful politician in Washington, pleads that he was doing what "everybody was doing," but is nonetheless **sentenced** to three years in prison.

January 11 Amy Chua's instantly controversial and even divisive memoir about parenting based upon what she sees as the Chinese way of doing things, ***The Battle Hymn of the Tiger Mother,*** arrives in bookstores. The author is a 38-year-old Yale law professor of Chinese descent whose chronicle of raising two daughters with a tough-love method becomes a huge best-seller as well as a cross-cultural conversation piece.

January 19 Chinese President Hu Jintao attends a White House state dinner hosted by President Obama and Michelle Obama, following a visit during which Obama has pressed Hu on the progress of **human rights in China**. The lavish gala is American-themed at the request of the Chinese delegation, finishing with apple pie and ice cream.

January 20 One hundred and twenty-five alleged crumb-bums linked to seven mob families that are said to be doing business in several states are arrested on charges of murder, racketeering, gambling, extortion and so forth: the **biggest roundup in FBI history**. Included in the sweep is the former boss of the storied Patriarca crime family, Luigi Manocchio, 83, who allegedly diverted authorities decades ago by disguising himself in women's apparel. Is this, at long last, the Twilight of the Godfathers?

January 25 An Alabama-based law firm sues Taco Bell, claiming that the fast food chain's taco filling is only 35 percent meat. The lawsuit is later dropped, but not before Taco Bell spends millions on a public relations campaign that includes a full-page **thank you for suing us** ad disclosing the ingredients of its suddenly "not-so-secret recipe."

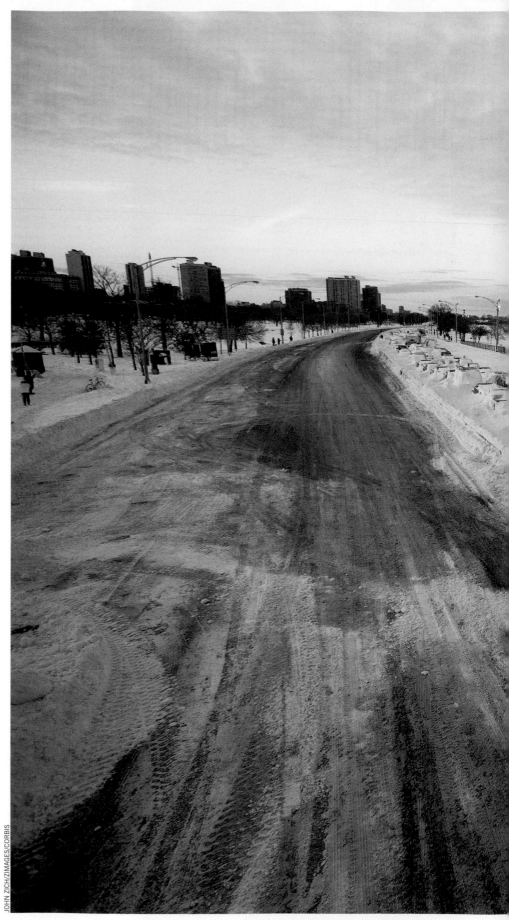

The Windy, and Snowy, City

Bulldozers and tow trucks had to accompany the plows on February 2 to clear snow and free scores of cars stranded on Chicago's Lake Shore Drive for over 24 hours following a blizzard that dumped more than 20 inches of snow. Tens of thousands were left without power, while nearly as many schoolchildren broke out the sleds and reveled in the piled-up snow days. There was no reprieve during the winter in the Midwest (and Northeast, too), and when the snow pack melted in spring, it caused record flooding along the Ohio, Mississippi and Missouri rivers as far south as Louisiana (please see page 32). What can we expect this coming winter? Well, we, of course, rely on the *Farmers' Almanac*, which is calling for more "clime and punishment": unusually cold and stormy weather, frigid in places, with, generally, lots of rain and snow. Wax those runners, kids.

February 7 The online Google Earth application allows Professor David Kennedy, an archaeologist based in Perth, Australia, a platform from which to discover **1,977 potential archaeological sites** in the Arabian Peninsula, 1,082 of which are ancient stone tombs. Kennedy asks a friend in Saudi Arabia to confirm the legitimacy of two of the sites with a more hands-on approach—a car and a camera.

February 9 Over the course of a six-year experiment, a border collie named **Chaser has learned 1,022 words**, a vocabulary comparable to that of a three-year-old child and larger than that of any other dog in the world, and today she gets her treat: a gig on the *Today* show. Her owner is Dr. John W. Pilley, a psychologist from Spartanburg, North Carolina, who trained her as a puppy for four to five hours a day. She knows what "doggie" means, obviously, but also "SpongeBob."

February 9 In other Internet news, the New York City–based blog Gawker breaks the story of Representative Christopher Lee, a married Republican congressman posing in an online "Women Seeking Men" forum as a **"divorced" "fit" "lobbyist."** Three hours later, the freshly minted "Craigslist Congressman" resigns in the first of New York's 2011 digital-age congressional scandals. Anthony Weiner apparently pays no heed.

February 10 Still online: Rebecca Black's **"Friday" music video** premieres on YouTube and quickly goes viral with well over a hundred million views. The video inspires bizarre reactions as the 13-year-old Black gains overnight fame, receives death threats, is dissed by Miley Cyrus (who later says she was misquoted), hosts MTV's first online awards show and finally, in pop culture's ultimate encomium, has her song covered on *Glee*.

JOHN ZICH/ZIMAGES/CORBIS

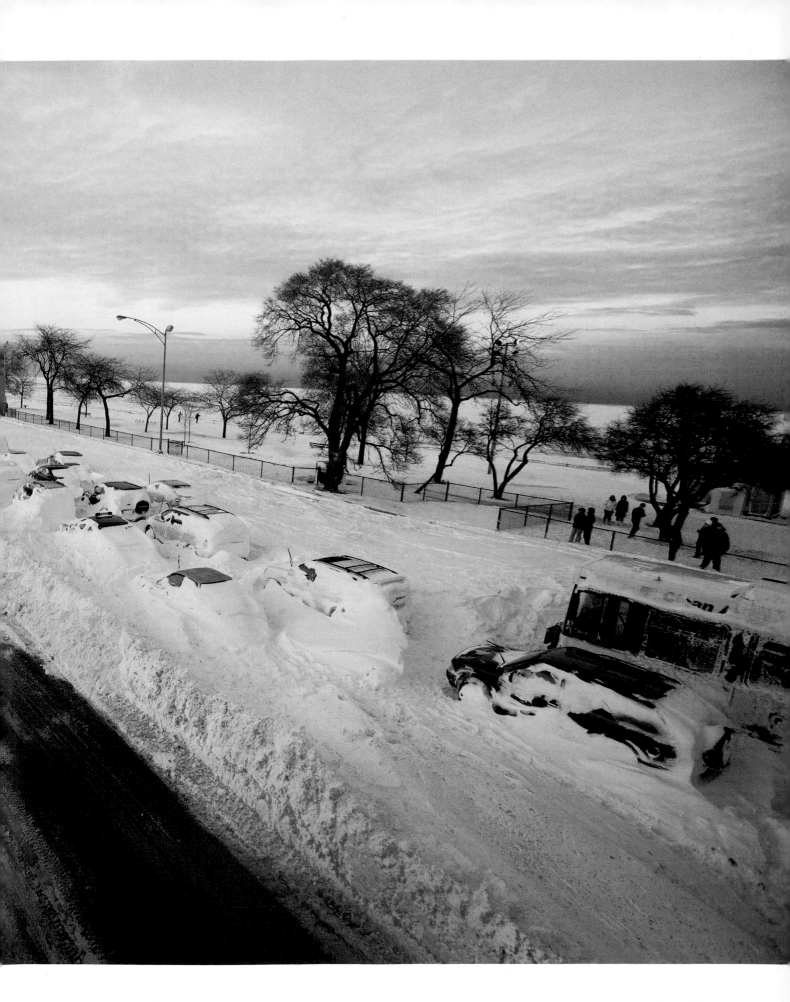

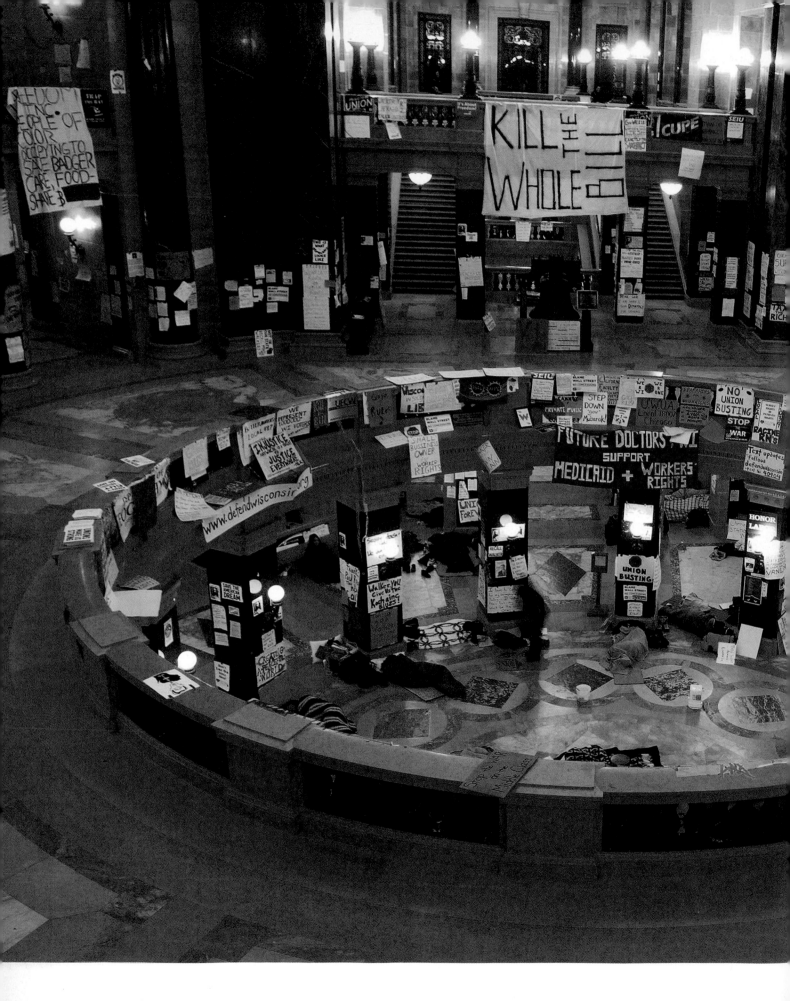

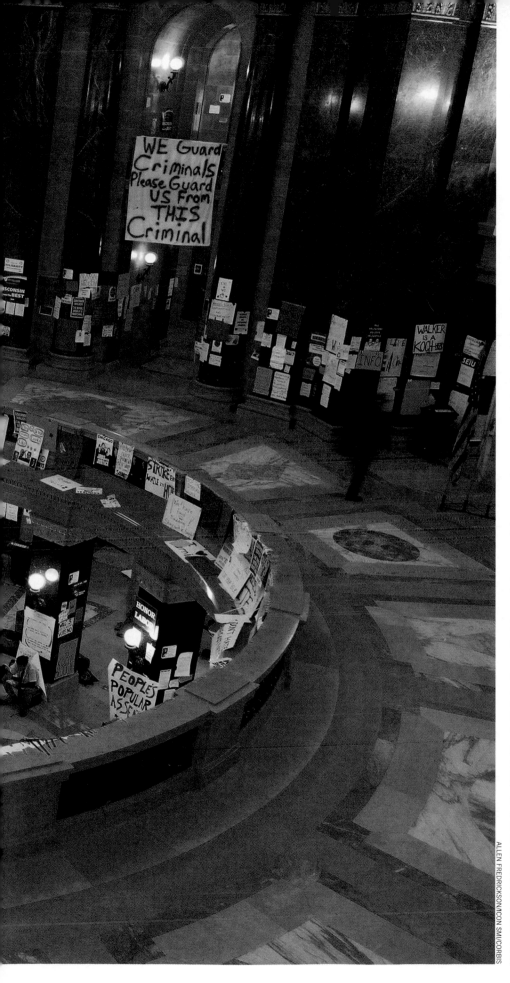

Hoping for a Wake-up Call

A wake-up call, yes, but for whom? That was the central demand of the contentious 2011 political debate, but everyone seemed to want only the opposition to "wake up" to the obvious; meanwhile legislative initiatives slept and the economy dozed, wheezed, snorted, rose, sank and rolled over again. That's a bedtime metaphor, and here's a metaphoric photograph for the year: On March 3, activists sleep on the floor of the capitol rotunda in Madison, Wisconsin, on the seventeenth day of their protest of Governor Scott Walker's "budget repair bill." To some, the bill, which rolled back collective bargaining, looked like union busting. Walker said: "For us, we're doing this to lead the way in our own state, to get Wisconsin working again." But he added that if this measure, which he signed into law in March and which was immediately met by legal challenges, could "inspire others across this country, state by state and in our federal government . . . I think that's a good thing and a thing we're willing to accept as part of our legacy." The debate rages on.

February 13 Lady Gaga arrives at the 53rd Annual Grammy Awards inside an **opaque egg sedan.** Certainly this references her album *Born This Way,* but it is also prophetic of the upcoming months when her star is well and truly hatched (please see page 100). Gaga eventually takes the No. 1 spot from Oprah Winfrey on *Forbes's* Celebrity 100 list for her 90 million in earnings, 32 million Facebook fans and 10 million Twitter followers.

February 16 Yet another Internet-related news flash: **Borders files for bankruptcy.** After starting out as a used-book store in Michigan, Borders became a publishing-industry powerhouse only to falter with the advent of the e-book. The last Borders store shutters in early autumn.

February 22 The School Board in Providence, Rhode Island, votes 4–3 to send **preemptive termination notices** to the 1,926 teachers in its public school system. The teachers continue working, but with the knowledge that they could be fired at any moment in order to balance a multimillion-dollar budget deficit. The action highlights two issues that are part of the discussion in 2011: the economy generally and the value society does or does not put on public education.

February 24 TV's top-rated sitcom, *Two and a Half Men,* is shut down by Warner Bros. Television and CBS after its star **Charlie Sheen** takes his grievances with the show's producer to the airwaves. Sheen will continue to hold the public's attention when he launches the 20-city "My Violent Torpedo of Truth/Defeat Is Not an Option" tour in the spring. In September, the first episode of *Men* starring Sheen's replacement, Ashton Kutcher, sets a sitcom ratings record.

Japan Is Shaken

The suboceanic megathrust earthquake on March 11 was huge—9.0 on the Richter scale, the most powerful ever known to have hit Japan and the fifth most powerful in the world since 1900—and it spurred tsunami waves of up to 33 feet in height that hurtled to the Oshika Peninsula of Tohoku, only 80 miles west of the epicenter. There was little warning, not that that would have helped, as the waves flooded as much as six miles inland. Here we see remnants of an enormous wave that has traveled the Heigawa estuary and is plowing into Miyako City. The tsunamis caused the kinds of massive human damage always associated with natural disaster—13,228 dead, 157,596 households without electricity, 320,000 without water—but as this occurred in thoroughly industrialized Japan, there were other problems still. The event provoked several nuclear-plant accidents, most crucially the level-7 meltdowns at three reactors in the Fukushima 1 nuclear power plant, which caused the evacuation of 185,000 people and was deemed the worst nuclear-power incident since the Chernobyl meltdown. The earthquake shifted the earth on its axis by perhaps as many as 10 inches, but it absolutely shattered Japan.

February 28 A British tabloid, *The Sun,* posts a video in which celebrated fashion designer **John Galliano, hanging in a Parisian cafe**, makes anti-Semitic comments and says that he "loves Hitler." Christian Dior immediately dismisses him as its chief designer.

March 2 The U.S. Fish and Wildlife Service declares that **the Eastern Cougar is extinct**. This branch of the cougar family, which also includes pumas, catamounts and mountain lions, was first threatened by European settlers in the 1700s and listed as an endangered species in 1973.

March 2 In a new book published by the Vatican, **Pope Benedict XVI pardons Jews** for the execution of Jesus, but still holds Jewish leaders of the time accountable. The exoneration is significant coming from the German-born pontiff who had, involuntarily, served in the Hitler Youth as a child, and in 2009 had revoked the excommunication of a Catholic bishop who had publicly denied the extent of the Holocaust.

March 2 Target Corporation settles a hazardous-waste dumping case by paying $22.5 million. The big-box retailer operates 235 stores in California and had been accused by state prosecutors of **various environmental violations**, such as pouring defective chemicals down the drain.

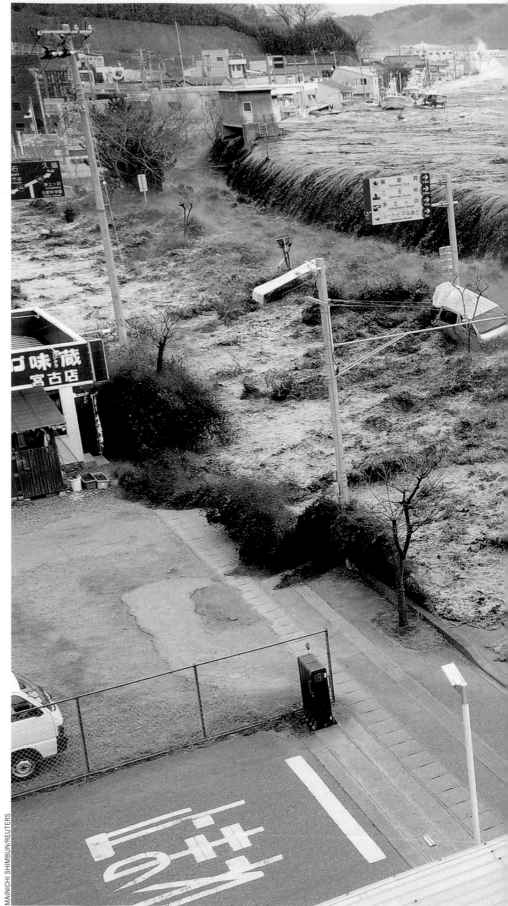

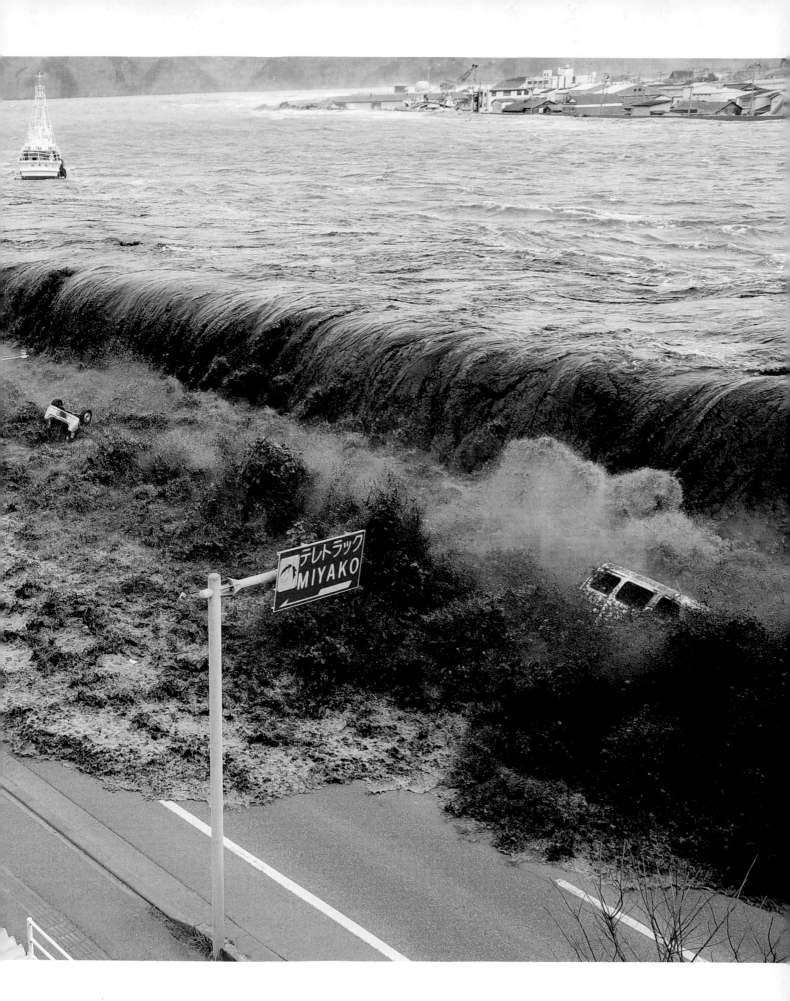

テレトラック
MIYAKO

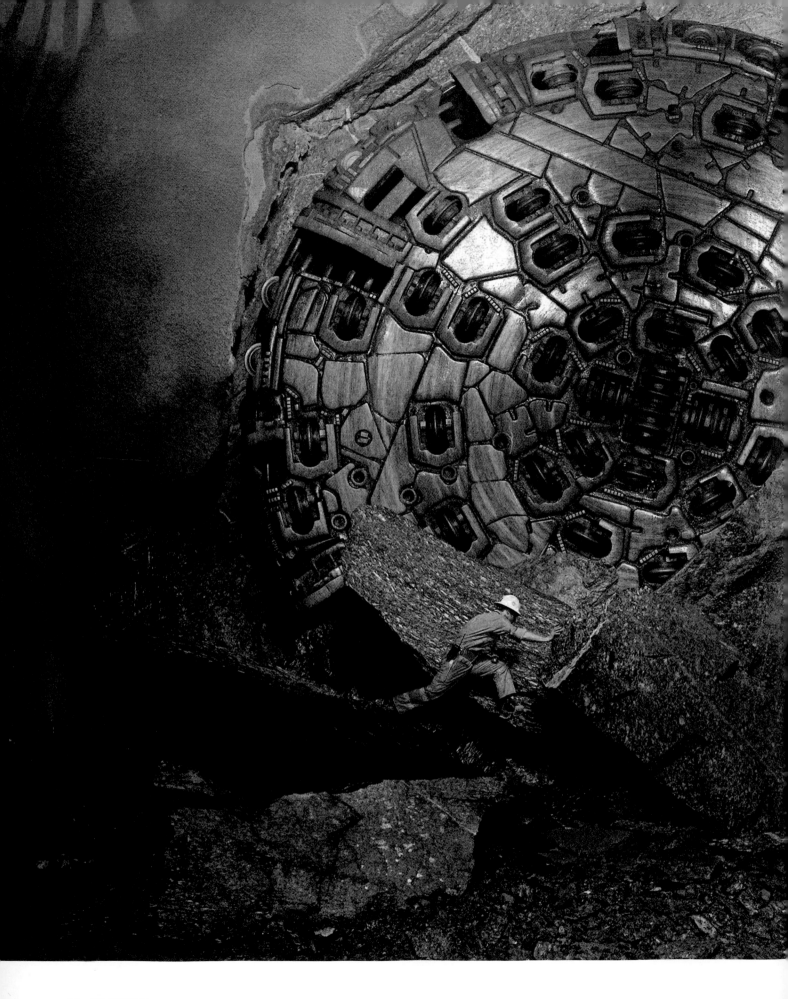

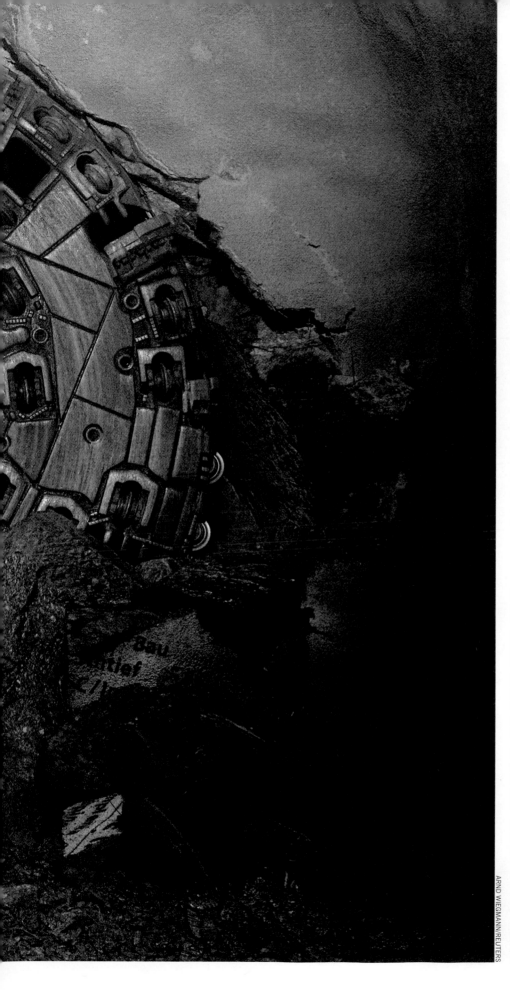

Dig This

In late March, a worker climbs on excavated rocks after a giant drill machine has broken through a vital section in the construction of the Gotthard Base Tunnel. Cutting through the Alps, the world's longest train tunnel should become operational at the end of 2016. The project consists of two parallel single-track tunnels, each 35 miles long: That's a lot of mountain to pass through. The train will eventually cut traveler time from Zurich to Milan by about an hour, but the real purpose of the tunnel is to abet the transport of freight and mitigate the need for ever more and ever bigger trucks on the roadways. Not so subtly, of course, in the current economic environment (Euro as well as American), the Gotthard Base project is an everyday reminder of an era when we got things done. Sixty-four percent of Swiss voters backed the launch of the initiative—way back in 1992. Would they be supportive today, in such a different world? In the Alps, they've already dug too deep to worry about that answer.

March 8 A National Public Radio executive is caught on video **calling the Tea Party "scary"** and **"xenophobic."** The following day, NPR CEO and president Vivian Schiller resigns, and conservatives in Congress gain traction in their efforts to block federal funding for the public broadcaster on the basis of liberal bias.

March 11 Dinner patrons in Covington, Kentucky, feel the full effects of the **Ohio River flooding** when their waterfront restaurant breaks free from its dock and drifts downriver mid-meal. The diners wait for rescue crews and are brought safely to shore.

March 14 The 14th **Dalai Lama steps down** as leader of Tibet's government in exile but will remain as spiritual leader of the Tibetan people. His announcement comes a month before a new prime minister is elected, and it indicates a move toward a stronger democratic authority.

March 21 Dallas Wiens receives the **first full face transplant** in the U.S. The 26-year-old Texan, who had suffered ravages to his features and nerves in an electrical accident, is operated on by a medical team of more than 30 at Boston's Brigham and Women's Hospital.

March 24 A Texas **beauty queen takes her fight to court,** claiming that pageant officials told her to "get off the tacos" and took back her crown after she had gained some weight. A jury rules in favor of 17-year-old Domonique Ramirez and gives her back the Miss San Antonio title.

The Tea Party

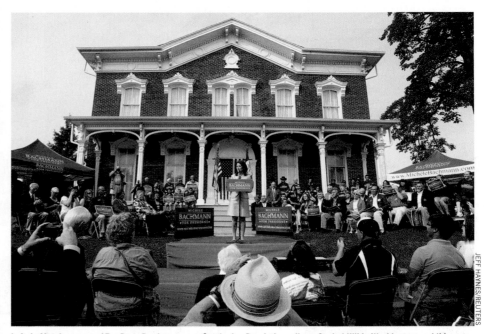

Left: In March a group of Tea Party Patriots stage a Continuing Revolution rally on Capitol Hill in Washington, and this man exhibits his love of country. Above: In her childhood hometown of Waterloo, Iowa, Tea Party favorite Michele Bachmann, congresswoman from Minnesota, addresses a gathering of supporters to formally launch her campaign for the 2012 Republican presidential nomination.

Its Founding Fathers (and many Mama Grizzlies) might assert that the contemporary movement was born on December 16, 1773, when Massachusetts radicals dumped tea into Boston Harbor in protest of taxation without representation, one of several acts of civil disobedience that led to the Shot Heard Round the World, the Revolutionary War and, ultimately, American independence. Our modern Tea Partiers say they are the philosophical and political descendants of those earlier Paul Reveres and John Hancocks and Sam Adamses, even if members of today's similarly dedicated cabal sometimes mess up the history, as when Minnesota congresswoman Michele Bachmann suggested in New Hampshire that she was proud to be in the state capital, Concord, where the fateful shot had been fired, only to be informed shortly later that the gauntlet had actually been thrown down in Concord, *Massachusetts*. New Hampshire, which would host the presidential election's first primary some months hence, was far more important to her campaign, and it was

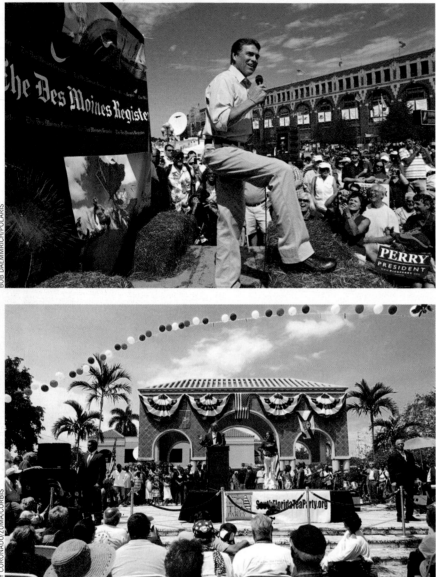

Below: Texas governor Rick Perry, who will play his Tea Party support against Mitt Romney's lack of it, eats a veggie dog and climbs the soapbox at the Iowa State Fair in August. Bottom: The Donald—surname Trump—tries to drink the tea early in Boca Raton, Florida, in April, but his trial balloon quickly goes *pffft*. Right: A month later, in May, Tea Party Queen Mama Grizzly Sarah Palin participates in the annual Ride for Freedom in Arlington, Virginia, hopping on a hog in the parking lot of the Pentagon. Opposite, below: Herman Cain lays out his bona fides to Tea Partiers, and they're buying. He will win the Florida straw poll over Perry, Romney, Bachmann et al.

BOB DAEMMRICH/POLARIS

GARY CORONADO/ZUMA/CORBIS

JIM LO SCALZO/EPA/CORBIS

unlikely that a Tea Party favorite would ever carry liberal Massachusetts anyway, so what the heck. She moved on, trailed by the hordes. She won the Iowa straw poll in midsummer and knocked a prominent Republican moderate, Tim Pawlenty, out of the race altogether. Within moments, it seemed, Governor Rick Perry of Texas had not only entered the race but, buoyed by Tea Party support, had replaced former Massachusetts governor Mitt Romney atop the polls. Just as suddenly, Romney, who theretofore had assiduously avoided the Tea Party and also discussion of his Mormon faith, was telling social and religious conservatives at the Palmetto Freedom Forum in South Carolina (an event not previously on his schedule) that, when making decisions as

President, he would "go on my knees" in seeking inspiration.

That's the thing about the Tea Party movement that has been a dominant force in American life in 2011 and surely will continue to be in 2012: a lot of excitement and energy, a lot of passion, a lot of immediate influence and more than a soupçon of confusion. Is it a political crusade? A religious uprising? Exclusively Republican? Vaguely Libertarian? What is it, exactly?

Since it prides itself on having no central organization, it remains, as 2011 draws to a close, hard to say. The Palmetto Freedom Forum, sponsored by the American Principles Project, was hosted by, among others, Senator Jim DeMint of South Carolina and Representative Steve King of Iowa, but

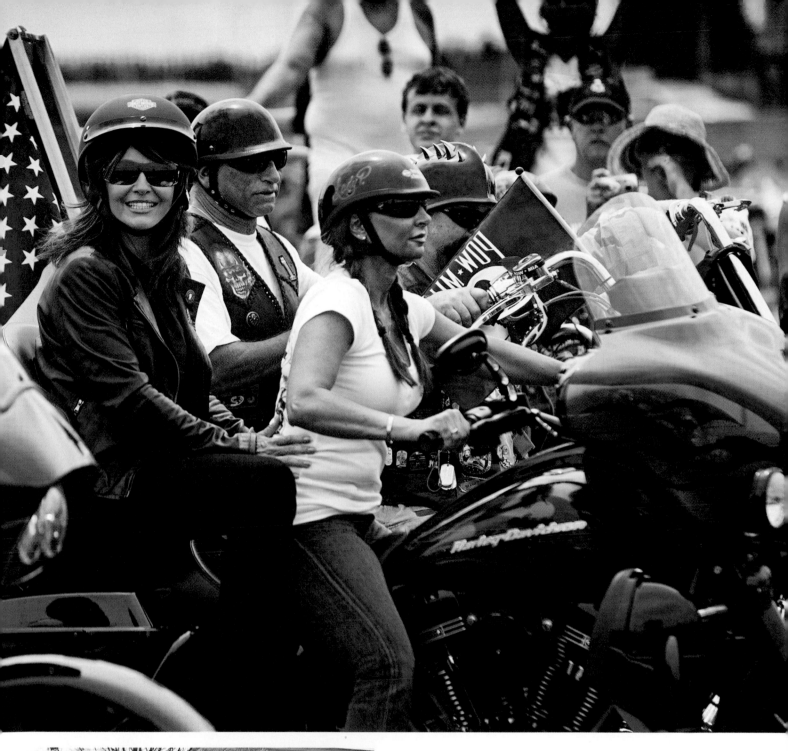

few would argue that either of them loomed nearly as large in the American imagination as queen bee Sarah Palin, who had shucked the cocoonish governorship of Alaska to evolve as a nationally prominent Fox News contributor and constant presence in the presidential debate—even though she wasn't running. And as to that debate: At Tea Party events to which Romney had been cordially invited, he was booed by Tea Partiers who saw themselves as far more dyed-in-the-wool.

How will this all shake out? Next year will tell, for the short term and maybe the long, for the Republican Party and maybe for the country. Meantime, while the economy falters in other areas, there is brisk business to be done in tri-cornered hats.

Gabrielle Giffords

O n January 8, the popular, bright and congenial congresswoman from Arizona, Gabrielle Dee Giffords, was staging one of her outreach sessions with constituents at a Safeway supermarket in her native Tucson, when a man opened fire. He left six dead, including a nine-year-old girl and a conservative U.S. District Court judge, and 14 injured—Giffords, critically, with a bullet to the brain. Blessedly, it had missed the most crucial parts of the cortex, and she would recover.

The attempted assassination of any government representative in a time of such political storm as the United States weathered throughout the year would have drawn attention and comment, certainly, but the shooting of Gabby Giffords was a catalyst of a unique kind. She was different. She was exemplary, and she was everybody—and the fact that there was no clear rhyme or reason to the attack made all of us wonder at what hateful point we as a society had arrived.

A Democrat, she was a former Republican who was regarded with deep affection and

NORMA JEAN GARGASZ/NEW YORK TIMES/REDUX

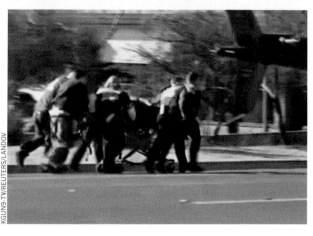

KGUN9-TV/REUTERS/LANDOV

Opposite: Giffords smiles at TIRR Memorial Hermann hospital in Houston on May 17, the day after the launch of *Endeavour* and the day before her cranioplasty. Top: Her wedding day in Amado, Arizona, on November 10, 2007. Above: Having been attacked. Right: The funeral service of nine-year-old Christina Taylor-Green, the rampage's youngest victim, at St. Elizabeth Ann Seton Catholic Church in Tucson.

MAMTA POPAT/EPA/CORBIS

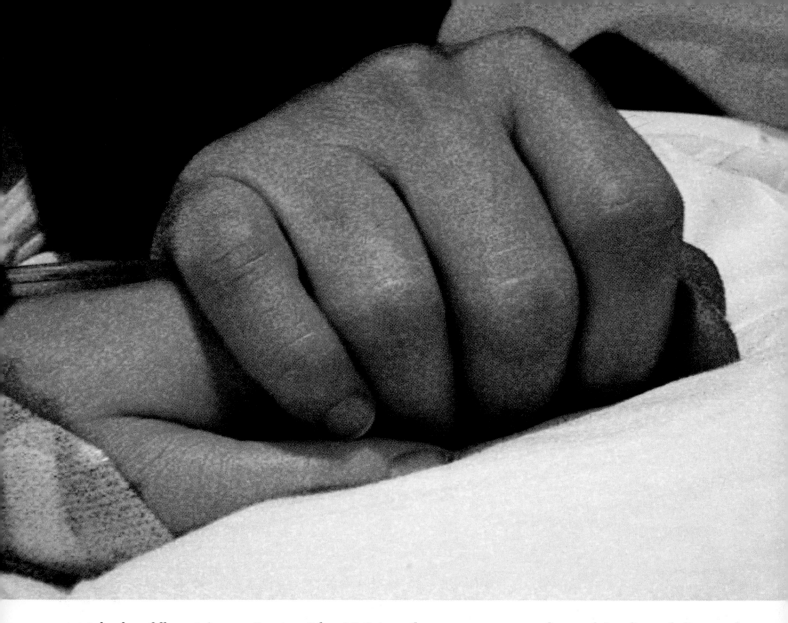

respect by her fellow Arizonan Senator John McCain. She was a woman—only the third to represent Arizona in Washington—and a Jew, Arizona's first ever to be sent to the capital. She was pro-choice, the recipient of a 100-percent rating by NARAL, and a staunch supporter of gun rights (she signed an amicus brief with the U.S. Supreme Court to support the overturn of a gun ban in Washington, D.C.) as well as tighter border control. She was a big proponent of solar energy and a big fan of the military; in fact, she was the only member of Congress married to an active military spouse, the Navy's Mark E. Kelly, an astronaut who later in 2011 would serve as commander of the final voyage of Space Shuttle *Endeavour*. She had supported President George W. Bush's Economic Stimulus Act of 2008, but was a critic of his No Child Left Behind education law. She had studied at Ivy League schools back East and was an avid reader; she was most comfortable when at home in the Southwest. She was a so-called Blue Dog Democrat and a member of the New Democrat Coalition, and involved herself in motorcycle safety issues because she dug motorcycles. She was herself, representing a constituency and explaining her views to

them at every turn—as she was doing that early January day in the parking lot outside Safeway.

The reaction as the national citizenry tried to come to terms with what had happened was of course compassionate and also very interesting. "God bless her, I hope she recovers," was predominant. And then: "I hope he's a madman."

The "he" was her attacker. Twenty-two-year-old Jared Lee Loughner was arrested and has been indicted on 49 counts by grand juries in Arizona. He has also been declared a schizophrenic incompetent to stand trial, and court proceedings against him were suspended in May. Loughner is undergoing psychiatric treatment at the U.S. Medical Center for Federal Prisoners in Springfield, Missouri, and the future of his prosecution, like that of Gabby Giffords's political career, is to be determined.

But the postscript of this terrible event brought general relief. When Giffords was well enough to return to Washington and vote to raise the debt ceiling in August, her colleagues welcomed her with tears and a standing ovation. Meanwhile, all Americans were allowed to reflect: *Well, this time, it was perhaps a crazy man. Not one of us.*

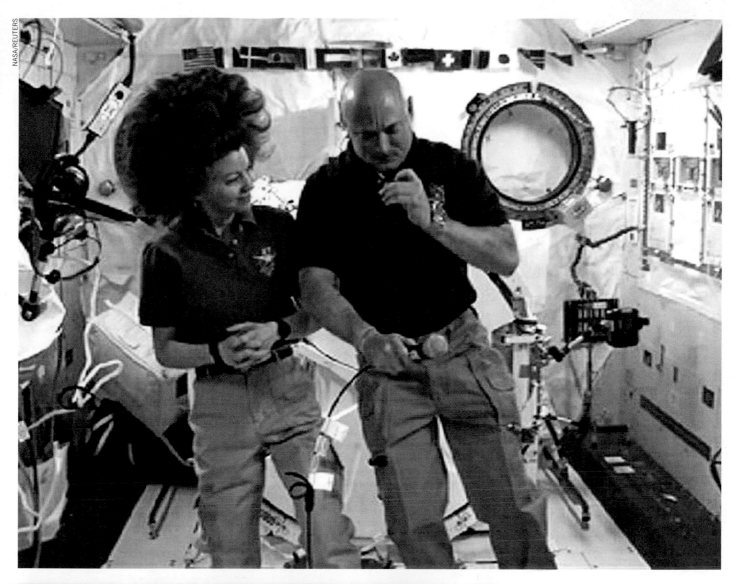

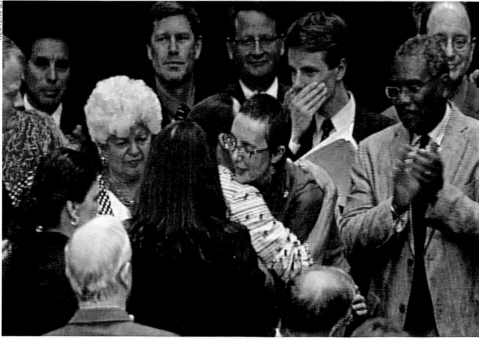

Opposite: On January 9, Giffords, in critical condition, is responding to simple commands, breathing without the aid of her ventilation tube, and holding her husband's hand. Above: On May 19, Commander Kelly of the *Endeavour* shows off his wedding ring, which he wears around his neck, during a news conference. (The weightless hair belongs to flight engineer Cady Coleman.) Left: On August 1, Giffords is embraced by colleagues on the floor of the House of Representatives after returning to Washington for the first time since she was shot. Needless to say, she receives a thunderous ovation from Democrats and Republicans alike, even though her purpose for being present is to vote in favor of the divisive bill to raise the U.S. debt ceiling and avoid a government default. Congressional warmth lasts just about until the applause dies down.

Spring

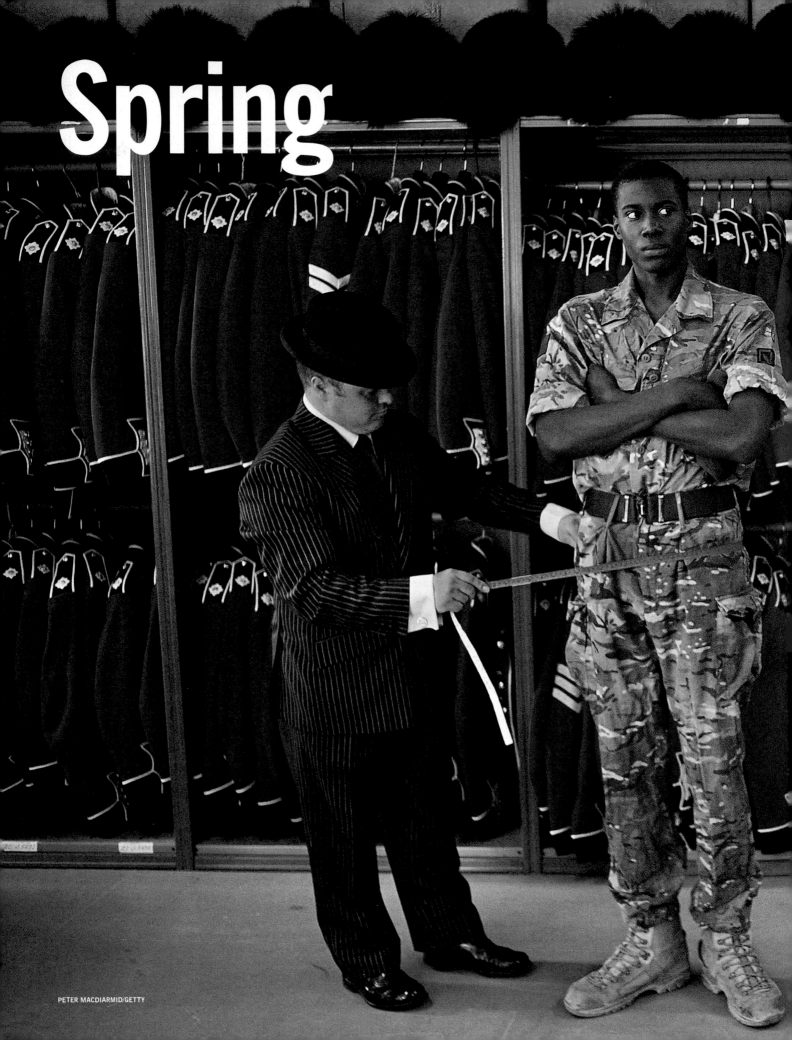

Goin' to the Chapel (Well, the Cathedral)

This photo depicts life getting easier—in some respects. Shot on April 21, eight days before the Big Day in London, it shows Irish Guardsman Bortnill St'Ange being fitted for a ceremonial uniform by Master Tailor Lance Sergeant Matthew Else in Victoria Barracks. Prince William, being measured elsewhere about this time, is the colonel of the regiment, which recently returned from service in Afghanistan and will be on duty at his wedding. The battlefront in everyday fatigues or Westminster Abbey in fancy duds? You'd have to ask Guardsman St'Ange which is preferred.

"We Got Him."

That's what you said to your spouse if you were still awake when the President spoke to the nation late on May 1. Or it's what you told your kids the next morning at breakfast, explaining to them why you had the TV news on as they readied themselves for school. This took everybody but a very select few by absolute surprise; it certainly took Pakistani authorities by surprise when they learned that an elite team of Navy Seals from the United States had, in the dead of night in Pakistan, executed a meticulously planned attack on a compound (right) in the city of Abbottabad, taking out the leader of the radical Islamist terrorist organization al-Qaeda, Osama bin Laden, who had declared war on the United States even before the attacks of September 11, 2001. Bin Laden, whose liberty as a fugitive had frustrated Americans for a decade, had been living in the compound for more than half of that time, as it eventuated. The questions came fast and furious in the aftermath of the raid. *Had Pakistan been protecting him?* Probably. *Was al-Qaeda finished?* No, but it had already been greatly weakened, and when, throughout the year, the killing of other leaders within the organization followed that of bin Laden, it diminished further. But for many in the country and throughout the free world, answers could be deferred for a day. What mattered: We got him.

April 1 Penélope Cruz receives a star on the Hollywood Walk of Fame. The Academy Award–winner and new mother is the very first Spanish actress to be honored with one of the iconic demarcators of having "made it."

April 1 Transocean Ltd., which built and staffed the Deepwater Horizon rig that poured crude oil into the Gulf of Mexico in April 2010, awards its executives **hefty bonuses** for their "best year in safety performance." Four days later, public outrage duly registered, five of the executives donate more than $250,000 to a memorial fund.

April 3 Chinese artist **Ai Weiwei is detained** by government authorities in the middle of a six-week crackdown on alleged dissidents. Ai, who vocally critiques the Communist Party through film, performance art and photography, is held under 24-hour observation for three weeks and becomes a focus of human rights advocates.

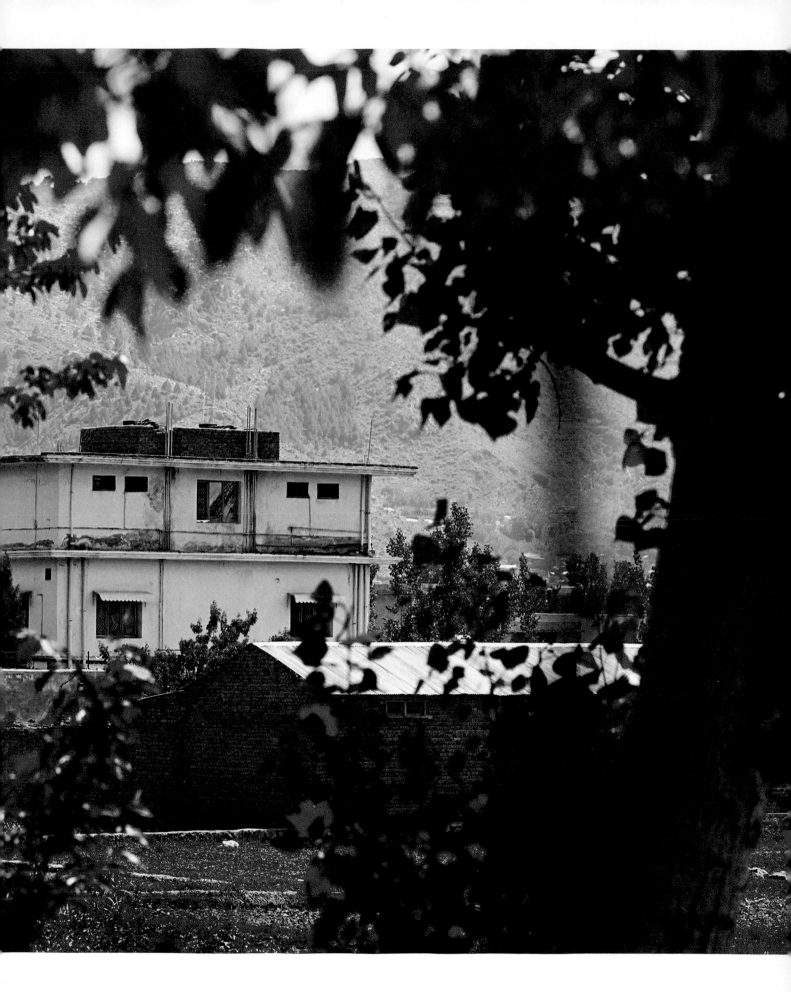

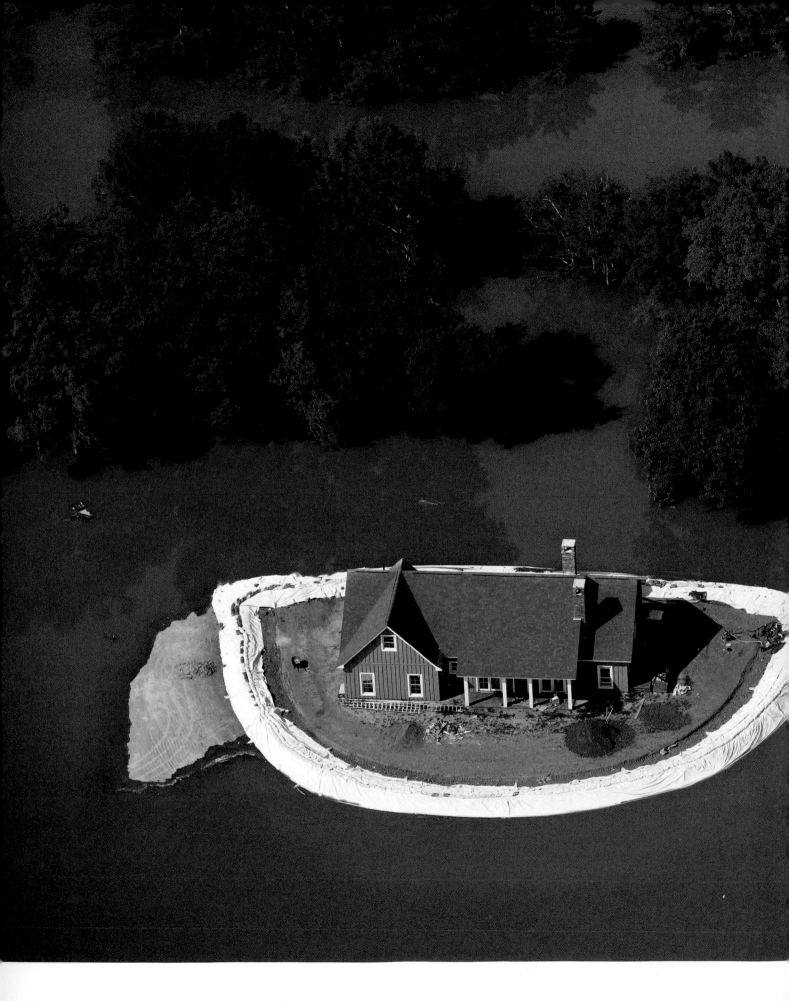

After the Flood

A house near Yazoo City, Mississippi, is protected by a curtain of sandbags in mid-May as the floodwaters of the Mississippi River near their crest. This is a placid, terribly beautiful picture that tends to belie the climactic violence that preceded it. In April, an unusually snowy winter was resulting in a huge snowmelt, which was bad enough, and then all hell broke loose in the country's midsection: four storms throwing off hundreds of tornadoes and record rainfalls that claimed nearly 400 lives, caused massive evacuations and generally created conditions for what some called "a 500-year flood." Because this is the modern day, the consequences didn't approach Armageddon, but large areas of Illinois, Missouri, Kentucky, Tennessee, Arkansas, Mississippi and Louisiana suffered; and the President declared parts of three states federal disaster areas. Even as the owners of the house seen here wondered what was next, so did citizens in New Orleans and Baton Rouge as floodwaters surged through the Louisiana bayou. In the event, the levees protecting the state's two biggest cities held.

April 3 Environmental degradation in Vietnam becomes a big issue when **a sacred turtle**, Cu Rua, is captured for medical treatment for lesions and sores that experts believe are consequences of pollution. A Vietnamese legend holds that a turtle—possibly Cu Rua himself—played a pivotal role in winning independence from China's Ming Dynasty in the early 1400s.

April 4 Three weeks after the tsunami, the Japanese Coast Guard saves a two-year-old dog found drifting on a slab of roof in Kesennuma, Miyagi Prefecture, one of the hardest-hit areas. The **dog has a joyful reunion** with its owner, who recognizes her pet from a news report on TV.

April 5 Ireland's first public civil partnership ceremony for a gay couple takes place. Barry Dignam and Hugh Walsh **seal their commitment** with a kiss in the Dublin registry office to the tune of Abba's "Dancing Queen."

April 6 Bob Dylan plays his first-ever concert in China but is criticized by some for leaving out classic protest songs, such as "The Times They Are A-Changin'" and "Blowin' in the Wind," during a time of especially intense crackdowns on Chinese dissidents in the country. Dylan states on his Web site that no censorship of his set list took place. In other words: **You go your way and I'll go mine**.

The End Is Near!
And Have a Pretzel!!

So what was the Rapture all about, anyway? Well, it was largely the figment of Harold Camping, an 89-year-old fundamentalist radio preacher from Alameda, California, who convinced many in his nationwide audience, including this woman in New York City, that on Saturday, May 21, earthquakes would erupt globally, the righteous would be called to Heaven, and the heathen would be left behind to wander a godforsaken planet that would be consumed in fire on October 21. It was all very specific, as had been an earlier Camping declaration that the world would end in 1994, which, by the way, it did not. It did not this past May, either, which seemed to disappoint Camping. On the Sunday after the Saturday in question, he said, "It has been a really tough weekend." He was, presumably, speaking about his personal weekend—lots of other people had enjoyed baseball, cookouts and such. He admitted to being "flabbergasted." He added: "I'll be back to work Monday and will say more then." The pretzel pushers in New York were back to work too.

April 19 Fidel Castro resigns from the Cuba Communist Party's Central Committee, signaling an eventual passing of the torch to a new generation of leaders. This marks the first time in the party's history that the 84-year-old revolutionary has not been one of its top leaders. His brother Raúl takes charge.

April 26 Belgium marks **a year without a full government**, surpassing the world record set by Iraq in November 2010 for having no coalition administration. The country's divisive politics are rooted in its Dutch- and French-speaking counterparts, which share little culture. Many wonder if the country should remain united. Stay tuned, Brussellistas.

April 27 More than 130 tornadoes storm through the South, hitting Alabama the hardest, razing entire neighborhoods and towns, and leaving **victims under rubble**. Nearly 300 people are killed. This caps a month that has already seen the most U.S. tornadoes in 36 years. And worse is in store (please see page 36).

May 1 Already on the fast track to sainthood, **Pope John Paul II is beatified** in Rome after a nun's recovery from Parkinson's is the first miracle attributed to the late pope—the quickest beatification-after-death in Roman Catholic history. A second miracle must be approved before the saintly title "Blessed" is conferred on John Paul.

Twister

The plague of tornadoes that accompanied the April storms in the Midwest and South (pages 32 and 34) was followed the next month by even larger twisters, one of which leveled sections of southern Joplin, Missouri, when it roared through at 5:41 p.m. on May 22. This was classified as an EF5 multiple-vortex tornado, which translates as a true monster—it was a mile wide at one point. Killing 162 people (including a police officer who died from a lightning strike when working cleanup the next day), it was the nation's seventh deadliest tornado—ranked 27th in world history—and perhaps the costliest ever to hit the U.S., causing more than $2 billion in damages. The tornado flattened whole sections of the city—houses, schools, stores—and it continued to intensify as it traveled through. Joplin had never experienced a horror like it. Few places had.

May 15 The Internet craze called **planking**, a recreation where participants make like a wooden plank, face down, in various crazy locations, takes a tragic turn when a 20-year-old in Brisbane, Australia, plunges to his death. He had been planking on a seventh-floor balcony overlooking Main Street, and his friend was snapping the photo they hoped to upload to one of the many sites devoted to planking.

May 17 A red-stater who likes blue boxes: Less than a week after Newt Gingrich enters the Republican presidential race, his candidacy becomes late-night comic fodder when it's revealed that he may still owe up to half a million dollars in credit card debt to Tiffany & Co. A month later, the revelation of a second line of credit with the high-end jeweler leads more to wonder aloud **whether Gingrich should be in charge** of the Treasury—among other things.

May 17 A farewell double episode of *The Oprah Winfrey Show* is taped in Chicago and attended by a celebrity-packed crowd of 13,000. It airs in advance of Winfrey's actual final show on May 25. Winfrey will not be absent from the airwaves for long: In October her new prime-time series bows on her own network.

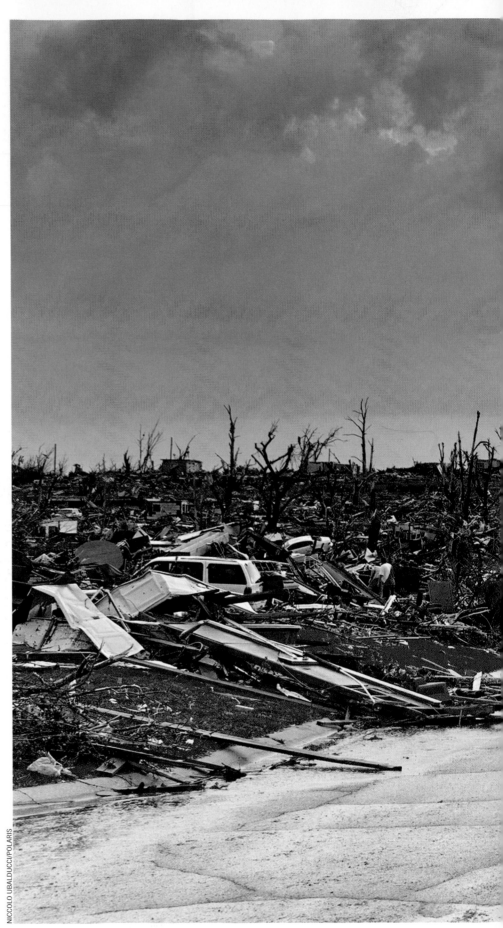

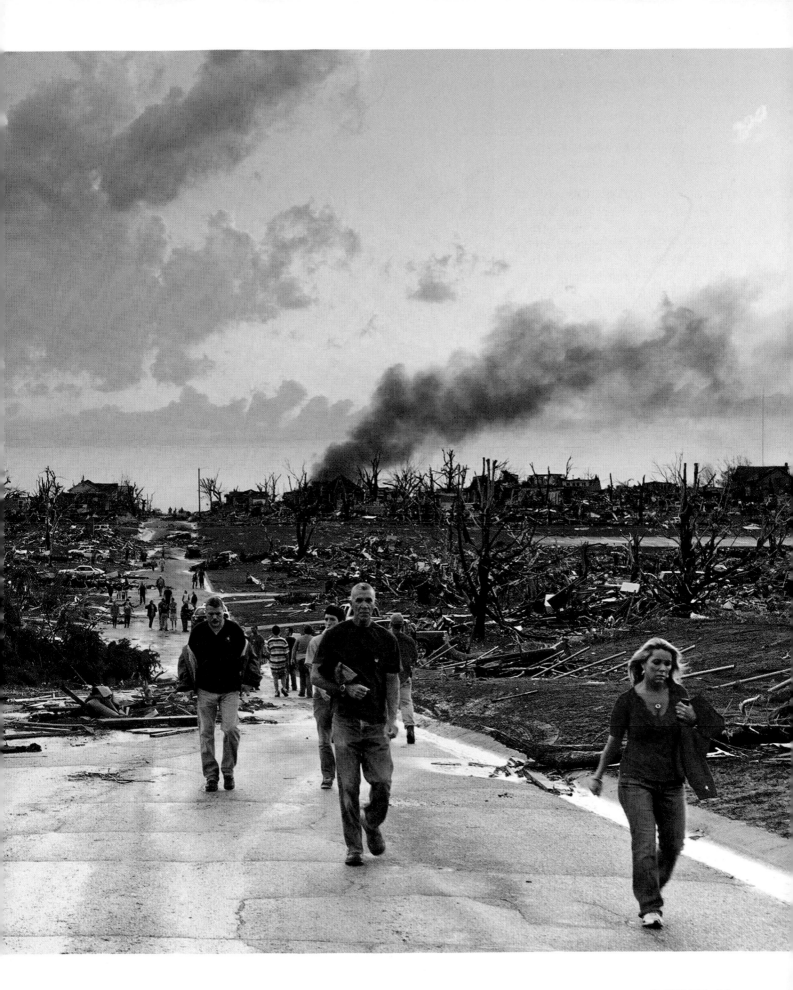

Drought, Famine—Again

It seems that every year in our annual review we can choose a beautiful, heartbreaking photograph from one African famine or another, one African refugee camp or another. But that is no reason not to choose one (or more than one); we cannot and should not look away. Here, in Mogadishu, Somalia, a mother and child are part of a queue for food—a long queue, as there are nearly 30,000 unfortunates at the newly established Badbado camp for Internally Displaced People. The situation in Somalia remains dire, with no end to the prolonged drought that has afflicted the country, and parts of neighboring Ethiopia and Kenya, for nearly four years. Not long after this photograph was made, the head of the U.N. refugee agency said that drought-ridden Somalia was the "worst humanitarian disaster" in the world. The World Food Programme estimated that 10 million people needed humanitarian aid, and the U.N. Children's Fund said more than 2 million young were malnourished and in need of lifesaving action.

May 18 Having learned nothing from the fate of designer John Galliano (please see page 15), Danish filmmaker **Lars von Trier jokes** about being a Nazi during a press conference for his film *Melancholia* and is banned from the Cannes Film Festival. Then he turns from stupid to Solomonic, announcing his retirement from public speaking. Good move; too late. This bizarre 2011 phenomenon of public flameouts tied to Hitler-riffing isn't yet done, and we'll hear from Hank Williams Jr. in October.

June 2 Mitt Romney, the former governor of Massachusetts, announces his second **run for the presidency** at Bittersweet Farm in Stratham, New Hampshire, and is anointed the Republican front-runner. But the Tea Party hasn't come at him yet, and when it does he seems uncertain whether to join them or try to beat them.

June 2 After placing 20th the year before, 14-year-old Sukanya Roy takes the 84th Scripps National Spelling Bee title by correctly spelling *cymotrichous* (which means, just by the way, "having wavy hair"). When asked, upon accepting the trophy, how she feels, Roy responds, "It's hard to put it into words."

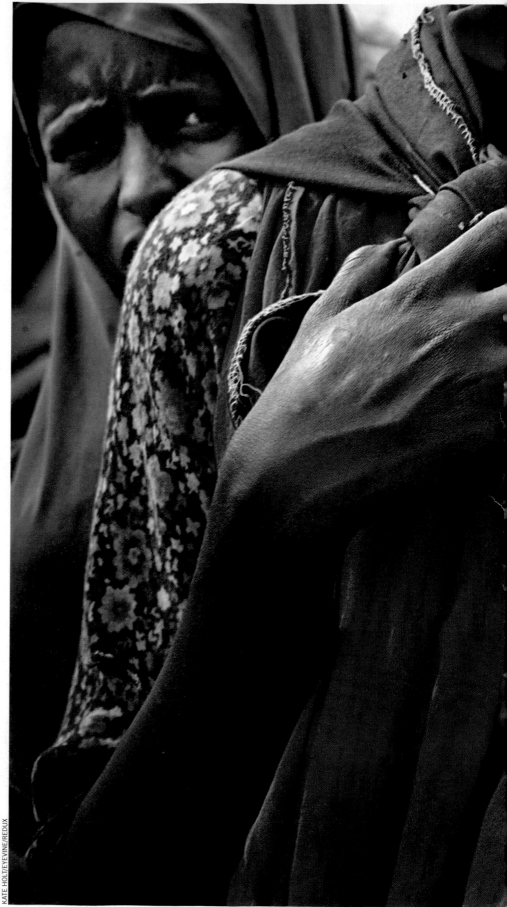

KATE HOLT/EYEVINE/REDUX

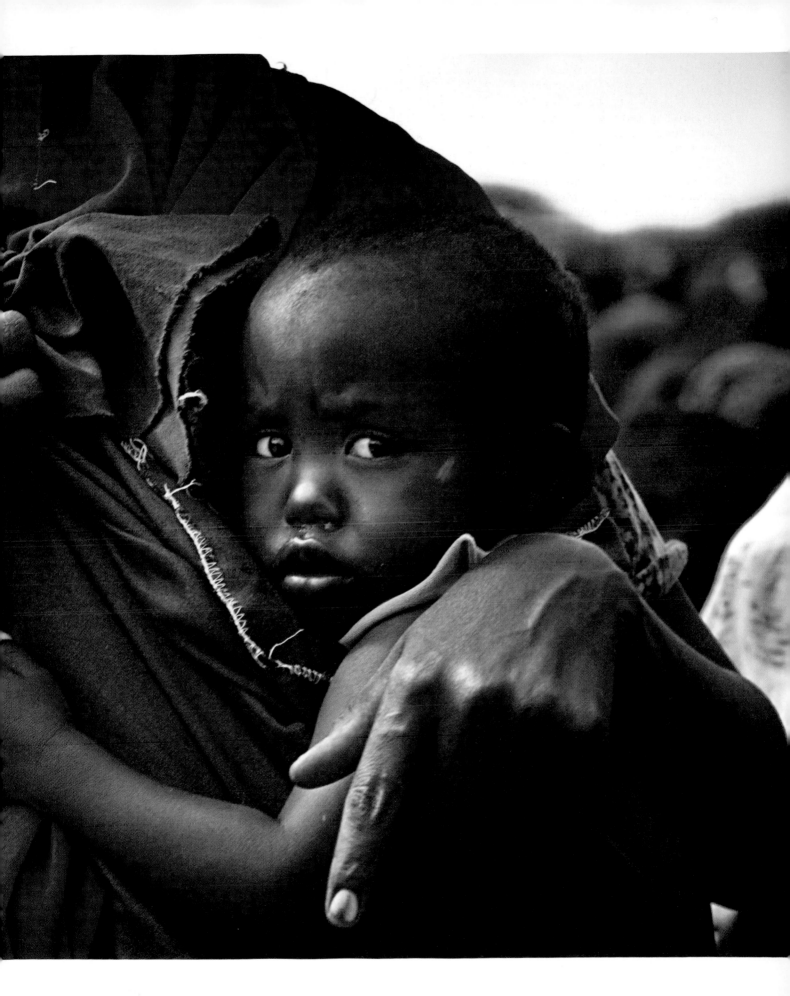

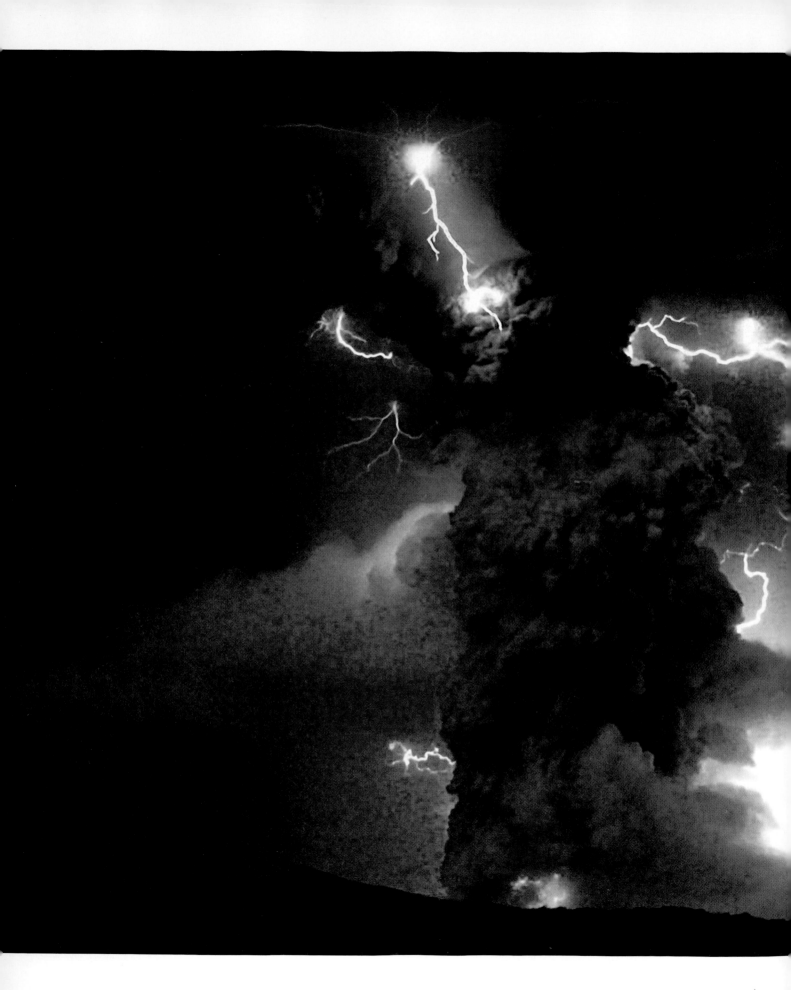

<div style="text-align: right; font-size: 0.7em; writing-mode: vertical-rl;">DANIEL BASUALTO/EPA/LANDOV</div>

Fire in the Sky

We in no way intend to diminish the magnitude of the first eruption of Chile's Puyehue volcano in a half century. The eruption, which began on June 4, was plenty big—ash shooting nearly six miles into the air caused the evacuation of 3,500 in the area and temporary airport closures as far away as Melbourne, Australia. Plenty big just on its merits, to be sure. But Puyehue's additional distinction, and certainly part of the reason for its presence in these pages, is that it threw off not just lava and ash but some of the most spectacular volcano photographs ever. In this one, made on June 5, the mountain's violence clashes with that of a lightning storm.

June 4 Li Na defeats defending champion Francesca Schiavone at the French Open to become **the first Chinese winner** of a Grand Slam tennis title. A hundred and sixty-six million viewers in her home country watch the victory on television. Later in the year, the Japanese women's soccer team upsets the U.S. in the World Cup final, and Asia suddenly finds itself with a surfeit of sports heroines.

June 9 In protest of the long-standing ban on women driving in the cities of Saudi Arabia, several dozen get behind the wheel and then share their **acts of defiance** through online videos and photos. Very little comes of this civil disobedience, and the ban remains in place.

June 11 Two **wildfires merge** into a 600-square-mile conflagration in eastern Arizona and thwart the efforts of more than 4,000 firefighters to get the resultant bigger blaze under control. The fire eventually becomes the largest in the state's history and spills into neighboring New Mexico. Before the last flame is extinguished, the wildfire will destroy 32 homes, four commercial properties, 36 outbuildings and 538,048 acres of land.

June 13 Vietnam holds live-fire naval exercises off its coast, another step in the escalating dispute with China over the oil- and mineral-rich territory in the South China Sea, to which the Philippines, Malaysia and Taiwan also have competing claims. **China is displeased**, saying Vietnam has "gravely violated" Chinese sovereignty. The feints continue; the resolution remains unclear; the situation remains tense.

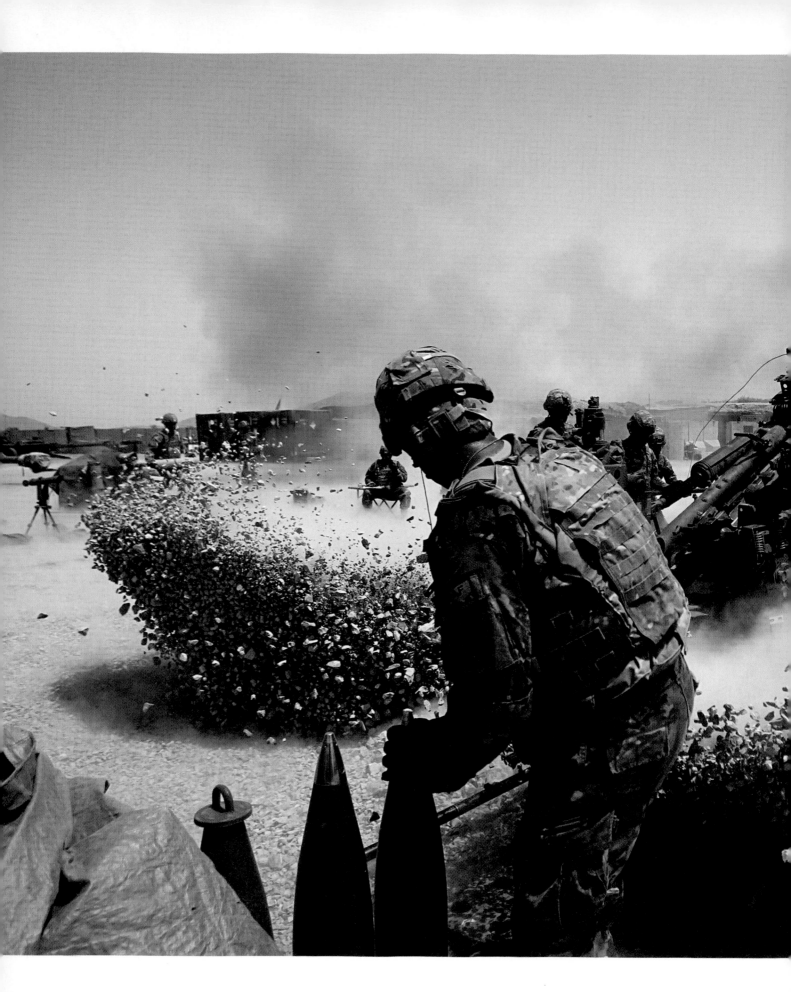

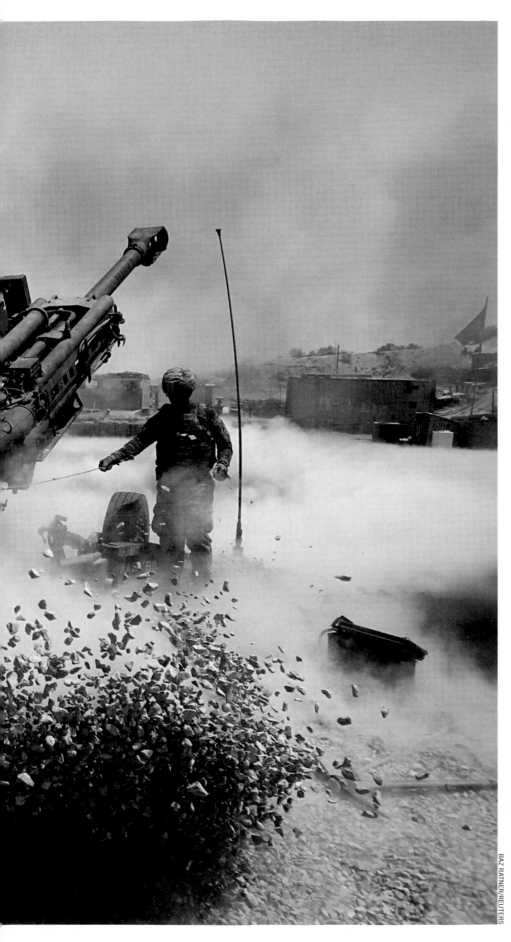

Still at War

On June 12, U.S. Army soldiers from the 2nd Platoon, B battery 2-8 field artillery, fire a howitzer at Seprwan Ghar forward fire base in the Panjwaii district of Kandahar province in southern Afghanistan. President Obama is planning drawdowns, Osama bin Laden has been killed—but a decade of the U.S. being at war continues. The Battle of Kandahar, beginning on May 7, is a centerpiece of the Taliban's spring offensive and includes attacks on eight locations throughout the city. On August 6, the Taliban shoots down a U.S. Chinook helicopter, killing 38, including 17 Navy Seals. Between these harsh reminders of what is happening on the ground, the President announces, on June 22, that 10,000 U.S. troops will be withdrawn by the end of 2011 and another 23,000 by the summer of 2012. If plans do not change, the United States is expected to exit Afghanistan by 2014. But what that might mean, and whether Afghanistan's own forces can secure the government—and the people—is, of course, unanswered.

June 14 A juror and defendant are convicted of contempt of London's High Court after **communicating on Facebook** while deliberations were still taking place. The incident causes a multimillion-pound drug trial to collapse. The contempt case represents the first prosecution of its kind in the U.K.

June 14 A previously unpublished Che Guevara diary is released in Cuba on what would have been the revolutionary's eighty-third birthday. *Diary of a Combatant* spans 1956 to 1958 and reveals details of his guerilla campaign that brought Fidel Castro to power. Che T-shirts are hot again.

June 15 After Vancouver loses to Boston in the Stanley Cup Finals, disappointed **Canucks fans riot**, setting cars on fire, looting stores and, in at least one case, making out in the street in a highly inappropriate manner. This isn't the first time Canucks fans have been bad losers: They also rioted after getting beaten by the New York Rangers in 1994. In both cases, beer fanned the flames.

June 15 A new federal analysis by the National Oceanic and Atmospheric Administration finds that with six more months to go, 2011 is already **a record-breaking year for extreme weather**, with $32 billion in related damages.

The Arab Spring

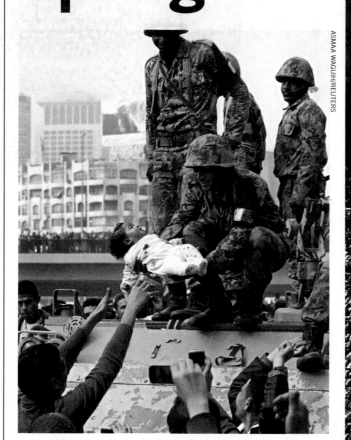

ASMAA WAGUIH/REUTERS

A tender moment during a demonstration: On January 29, as thousands gather in Cairo to demand that President Hosni Mubarak resign, a protester reaches out as a soldier hands down a child. The up-close photographs are telling about the mood of the people, but so are the pulled-back ones, which capture the immensity of the movement. Right: In Cairo's Tahrir Square on February 18, a day of prayer and celebration is called to mark the previous week's fall of Mubarak and to keep pressure on the new military leaders to steer the country toward democratic reforms. Opposite: In Cairo on March 19, Egyptians register at a polling station to cast votes in a referendum to change the constitution.

AHMED ASAD/APA/POLARIS

It began in advance of spring and continued until well after; it continues today and will tomorrow, with consequences uncertain. If the compass of the term—*Arab Spring*—is inexact, so is the connotation. Spring alludes to sunshine and flowers, to rebirth and renaissance. These were elements of the Arab Spring, to be sure, but so were violence and death, reprisal and recrimination.

From a Western vantage, the uprisings in the Middle East recalled for some the imagined romance of the 1960s, or the 1770s, or the fall of the Berlin Wall. For others, they begged a question: What does this all mean, going forth? There remains, as we enter 2012, no certain answer.

A democratic nation supports and encourages democratic principles, and so, by and large, the U.S. supported the efforts of Arab peoples to take back their countries from dictators and tyrants. Our politicians, pundits and populace cheered when on January 14, President Zine el-Abidine Ben Ali, in charge of Tunisia for 23 years, fled to Saudi Arabia following a month of protests that grew more violent by the day. On February 11, the forever president of Egypt, Hosni Mubarak, resigned and left his country in military hands until a general election could be held. In one of the most remarkable turnabouts of the Arab Spring, he would subsequently be put on trial for crimes against his people. On March 15, the

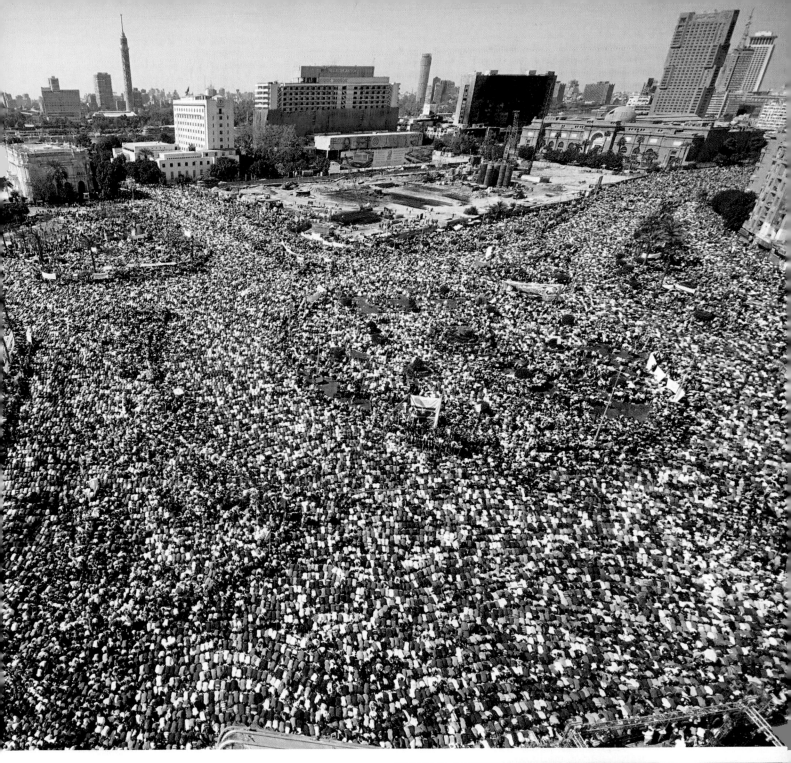

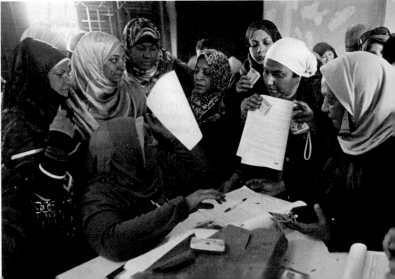

king of Bahrain, Hamid bin Isa al-Khalifa, declared a three-month state of emergency as his troops battled protesters.

And spring was still a week away!

Profound social change would continue to come to these countries, and all the while there were Libya, Syria and Saudi Arabia and much else to be discussed. Hadn't Mubarak been an eternal ally of the U.S.? How deep should our alliance with the Saudis extend?

Libya provides a perfect case of complexities: Washington never loved Muammar Gadhafi but abided him and his despotism for decades. In late February and early March, Middle East unrest caused worldwide uncertainty about

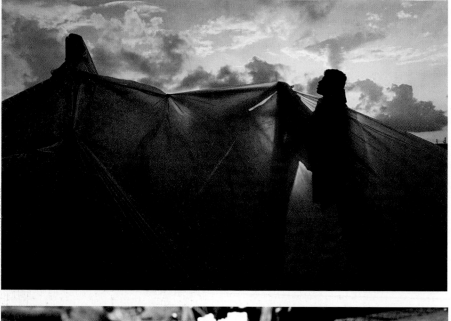

In Tunisia, all is turmoil. Left: On March 22, a man fleeing the unrest there stands in a makeshift shelter after arriving at the southern Italian island of Lampedusa. More than 5,000 North African refugees, most from Tunisia, have instantly doubled the small island's population and created a humanitarian crisis. Below, left: On May 10, a girl watches antigovernment protesters who are demanding the ouster of Yemen's president Ali Abdullah Saleh. In Libya, the battle for control truly was a months-long civil war. Right: In March, rebels run for cover in front of a burning gas storage terminal on a road between Ras Lanuf and Bin Jawad. Far right: By August, the tide is turning, and on the 23rd rebel fighters storm Muammar Gadhafi's main military compound. That day, some of the insurgents break the glass of Gadhafi's tent inside the compound, while nearby one of their comrades-in-arms chills, if only for a moment, with a soccer ball (below).

the Libyan oil output and prices rose by a fifth over two weeks. So the Arab Spring was, at the end of the day, the major contributor to this year's energy crisis. Then in mid-March, with the Libyan civil war flaring, the U.N. Security Council unanimously voted to create a no-fly zone over the country to deter the regime's brutalization of civilians. The tide turned grudgingly, and on August 22, Libyan rebels entered Tripoli. In late October, they got Gadhafi. Generally, we cheered.

And in the meantime: President Ali Abdullah Saleh of Yemen had fled (in June) to Saudi Arabia after being injured in an attack on his palace; thousands of Syrians had fled to Turkey (also in June) as troops cracked down on the revolt; and more than 100 people had been killed (in July) in a Syrian Army tank raid on the town of Hama, where dissension was rampant.

Obviously, all of this remains in play. As does the American response. Our political interests certainly include stability and oil production. Our political and philosophical ideals are harbored in democratic principles. What tomorrow holds, and how ideals might be compromised by realpolitik, no one knows—no one in Cairo, in Tripoli, in Washington.

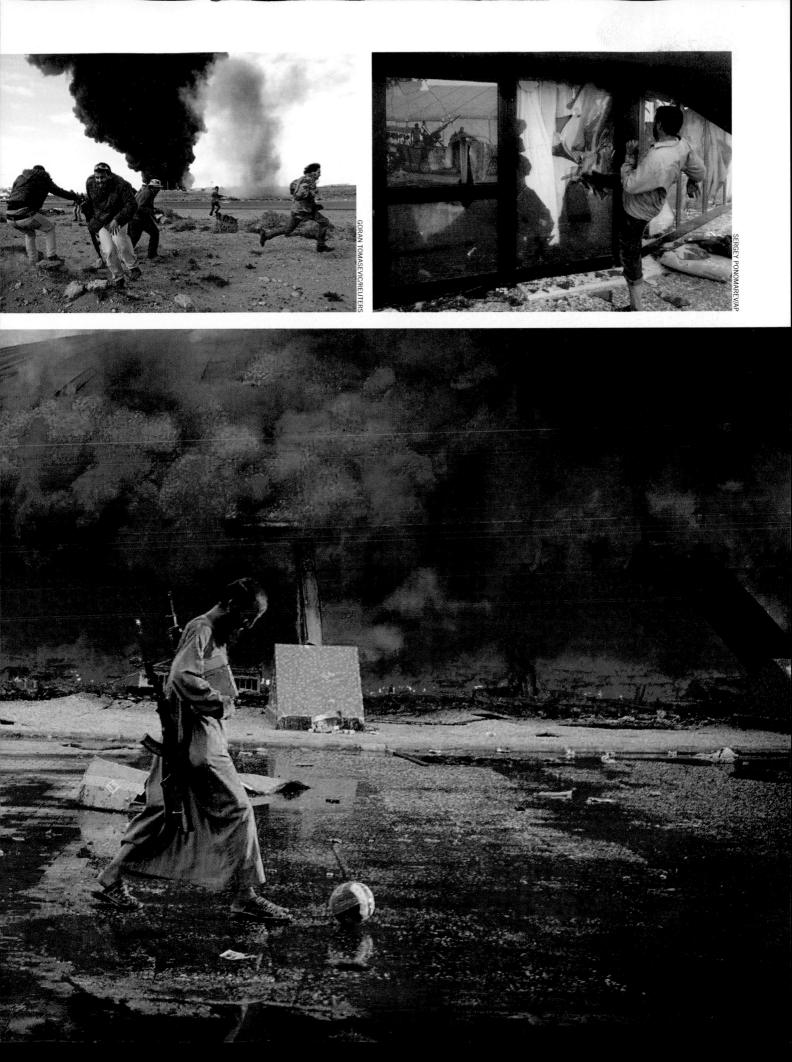

GORAN TOMASEVIC/REUTERS

SERGEY PONOMAREV/AP

The Cambridges

To a world needing a smile—needing a love story—Wills and Kate gave themselves.

Who were they before they became, on April 29, the freshly minted Duke and Duchess of Cambridge?

They were the innocent players in a trumped-up, modern-day Cinderella story. *Here came the bride*, the lovely Kate Middleton, who was in the cruel parlance of the royals "a commoner"—which is to say, *not from the aristocracy*. In other words, *one of us*. She and her gallant prince, William, of the ruling (if virtually powerless) Windsor clan, met at university in Scotland, fell hard for each other, and stayed true to their love through nearly a decade of wilting pressure from all sides. During the long while, the people out there were rooting for them: the millions in England and

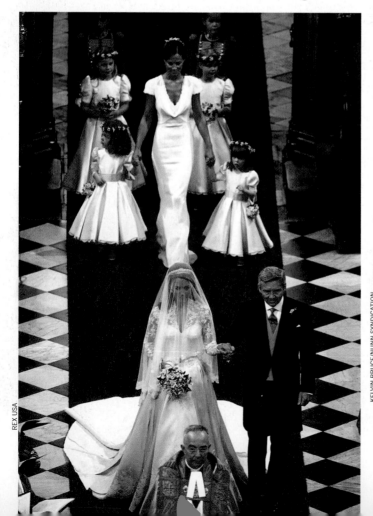

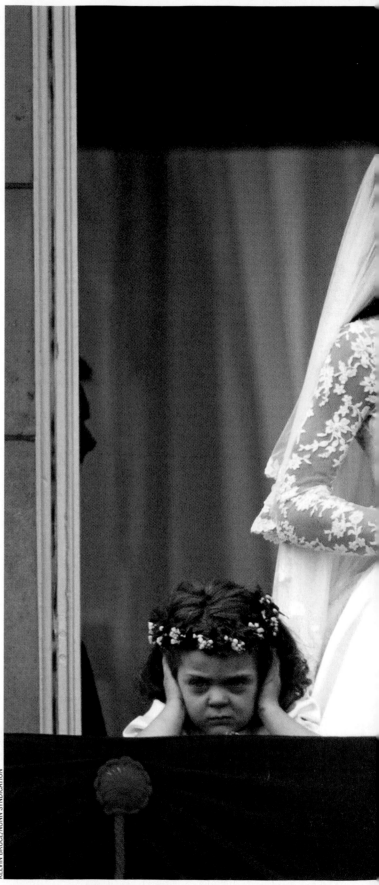

Left: Kate walks the aisle of Westminster Abbey on the arm of her father, Michael, as sister Pippa, who makes a big splash this day with her style and pizzazz, leads the bridal party.

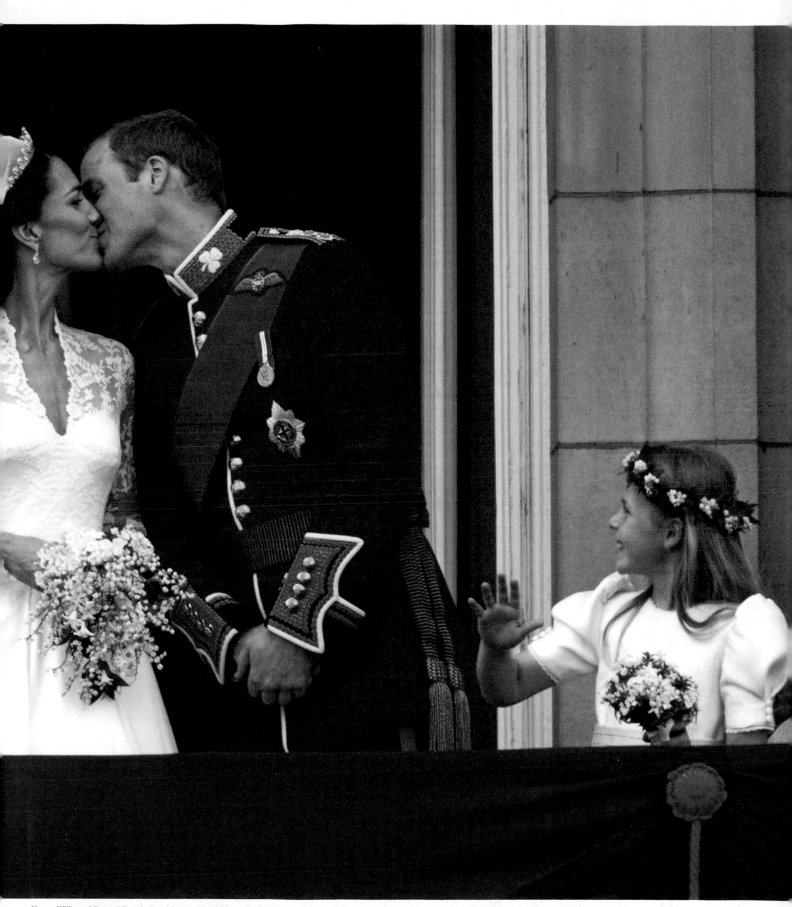

Above: Wills and Kate oblige their subjects with a kiss on the Buckingham Palace balcony while three-year-old bridesmaid Grace van Cutsem, William's goddaughter, covers her ears against the roar of the Battle of Britain flyover. The Cambridges are generous this day: two kisses, not just one.

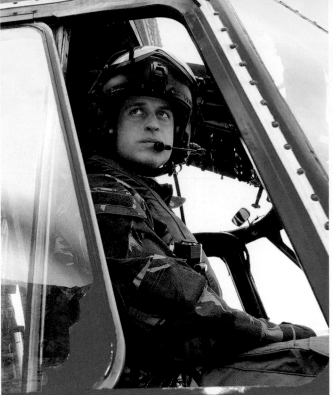

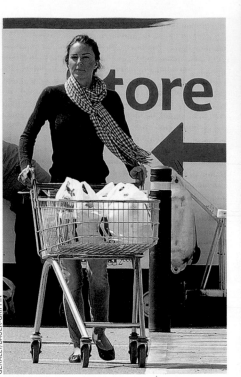

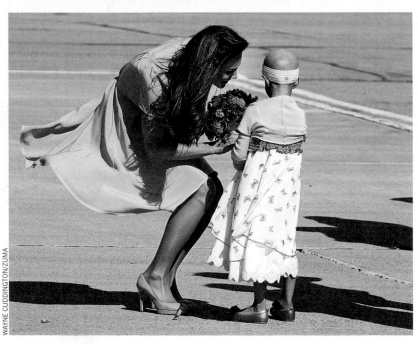

Wills and Kate settle in Wales, where the flight lieutenant continues his military career as a search-and-rescue pilot (above, left); he will probably serve up to three more years. Meantime, Kate thrills the locals whenever she takes to the supermarket. Of course, the Cambridges' real day job is to be the Cambridges: to represent their country admirably, to try to redeem the Windsor family's tattered reputation with their grace and youth, to boost various charities and causes, to make nice with children. They get right down to it, and their first international visit is to Canada, where Kate proves to be a second Diana among the people (left), while Wills wows the kids with equal charisma (right). In Los Angeles, during the next leg of their trip, they prove just as big a hit.

throughout the world who wanted to place a bet on true love and a fairy-tale ending (again, those millions being *us*). On April 29, we all got our wish, as alarm clocks rang in the United States, champagne corks popped in Australia, and 2 billion Subjects of Romance watched the extraordinary pageantry at Westminster Abbey and, then, *the kiss*—two kisses! A bonus kiss!—at Buckingham Palace.

There was so much subtext to this spectacle. The beloved and tragically deceased Diana was ever-present. The misdeeds of the Windsors, including those of William's father, Prince Charles, hovered gloomily, like Marley's ghost, in requirement of redemption. The whispered suggestion

that Kate and the rest of the Middletons had been deemed unworthy by Palace elders was on the table. The BBC and *Masterpiece Theatre* could have done well by this story, and no doubt will one day. (One day soon, is our bet.)

But Wills and Kate seized the reins, and brought it all off splendidly. If Kate's sister, Pippa, nearly stole the show with her semi-demure star turn (even as the year turns to '12, there remains debate about whether she had enhanced her already shapely figure for the big day; no firm evidence has been brought forth), the royal couple ascended gracefully to the uppermost echelon of international fame, then took their fabulous roadshow to Canada and, whoa!, Los

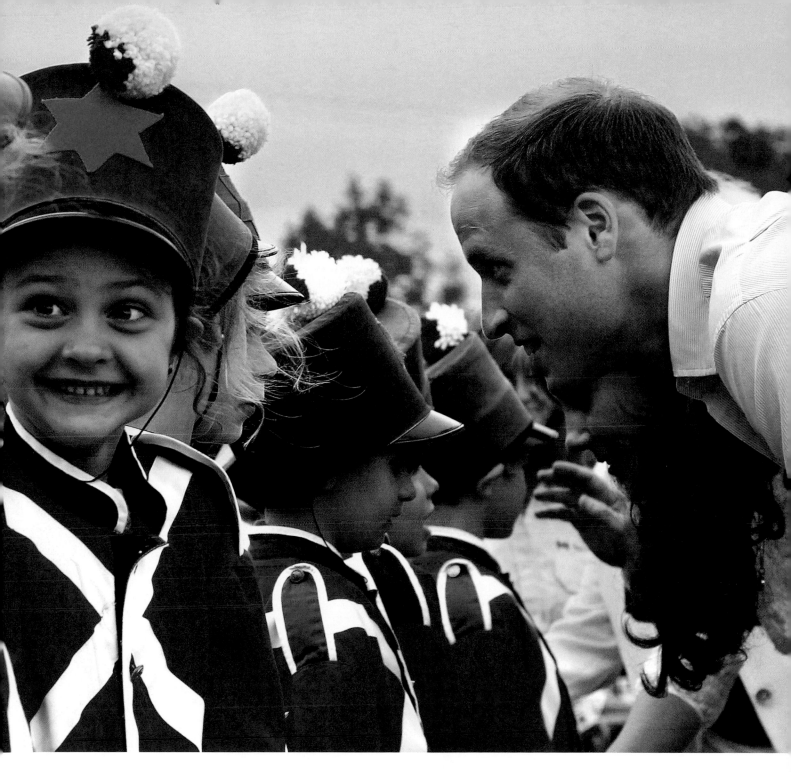

Angeles—the very epicenter of celebrity. Kate reinforced her reputation as a beautiful, ever-smiling and unflappable young woman, a pitch-perfect princess for the new millennium. Wills boosted the general hope that he, and not his somewhat odd father, will ultimately succeed Elizabeth II as England's sovereign.

That'll all be worked out in the fullness of time, of course—worked out to little real consequence. For now, there are parties to be partied and charities to be fronted. The Cambridges are game for the game, while William continues his career in the British military, as does his devoted younger brother, the rakish Harry, who of course served as Wills's best man on April 29. (Hey? How about Harry and Pippa? What think? You betcha; we're on board. Big time.)

We in America often have good sport with the British royals, and most of the royals seem okay with that. But sometimes we all should pause and regard a little more seriously, or at least fairly, Will and Kate: They seem fine young people. They haven't screwed up. We know they're smart. They seem to be in love. They seem to have made a sound choice in one another, ignoring at times the advice or disparagement of their elders.

We wish them well. We wish them all the best.

LIFE.com
Pictures of the Week

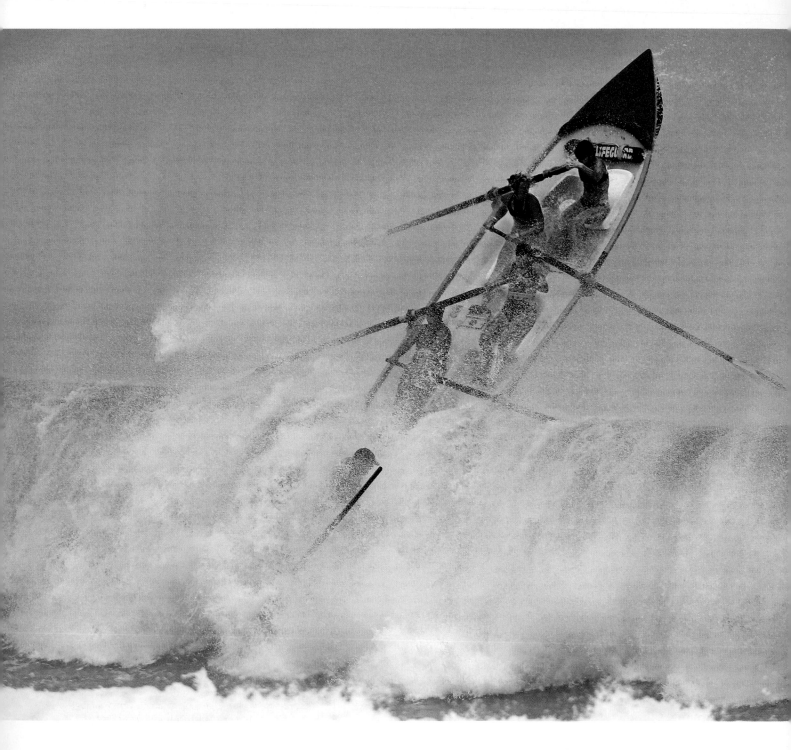

Our colleagues, our *brethren,* at LIFE.com are daily engaged in a variety of crowd-pleasing and imaginative enterprises—"never-before-seen" photography, subject-specific galleries in tune with the zeitgeist—that have drawn millions to their Web site, which includes as a bedrock the vast LIFE archive. There are 15 million images housed on LIFE.com, but the site is also right up to the minute, posting the latest great photographs from all over the world. The editors realize it is useful to filter these for their visitors and select the very best. Says Simon Barnett, LIFE.com's director of photography: "On any given week our editors look at in excess of 100,000 pictures. I get to whittle those down to the top 25 or so we call Pictures of the Week. We are different from most of the other 'best of' photo reports in that we attempt to honor the tradition of LIFE magazine by showcasing a photographic world fully rounded, depicting not only the bad news that is seemingly all around us these days but also the moments of humor and wonder and amazement, too. Our guiding mission for Pictures of the Week is to have our audience experience a full range of emotions—perhaps best encompassed, to borrow a phrase, as 'joy and pain, sunshine and rain.'" On these next six pages, some of LIFE.com's greatest hits, 2011, with Barnett's occasional commentary.

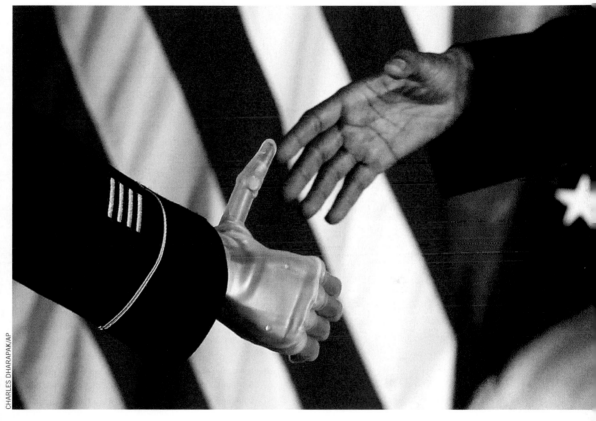

CHARLES DHARAPAK/AP

PHIL WALTER/GETTY

Surf's Way Up

On February 12, the Piha women's crew battles a large wave during the Day of Giants surfboat regatta at Piha beach on February 12 in Auckland, New Zealand. LIFE.com can introduce its audience not only to thrilling pictures but to fascinating subcultures around the world. Piha, for instance, was the first surf club on the west coast of New Zealand, started in 1934 by a group of five young men from the Waitemata Rugby Club. Its club colors are red for the sunset, green for the bush and black for the iron sands. The Piha club performs more ocean rescues annually than any other club in New Zealand, patrolling the beach from late October to Easter (that being spring and summer down there). It's also part of a reality TV show, *Piha Rescue,* now in its seventh season. Who would have known?

Reaching Out

In the East Room of the White House on July 12, President Barack Obama shakes the prosthetic hand of U.S. Army Sgt. First Class Leroy Arthur Petry of Santa Fe, New Mexico, who receives the Medal of Honor this day. Petry lost his right hand as he tossed aside a live grenade during a 2008 firefight in Afghanistan, sparing the lives of fellow Army Rangers. He has now become the second living recipient of the medal, joining Salvatore Giunta, who exhibited valorous action during the Vietnam War (Giunta is in attendance at the White House for Petry's ceremony). Petry is also the ninth recipient to be given the Medal of Honor for actions in the Iraq or Afghanistan wars of the past decade. Says LIFE.com's Barnett, reflecting on tough times and good times, hardship and heroism such as Petry's: "Seeing the constant influx of images of conflict and famine and strife can be a little depressing for sure, but looking at the world through the eyes of press photographers can be uplifting too."

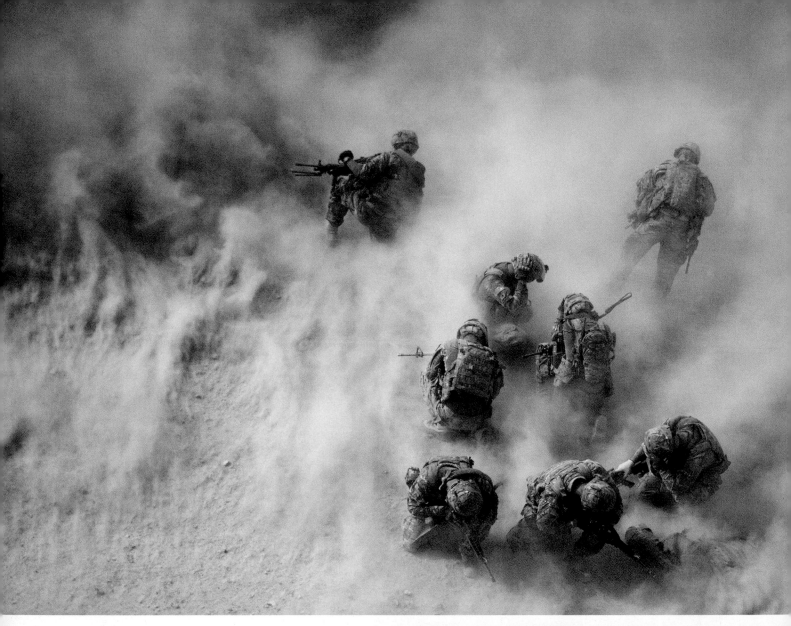

War's Trials

In Afghanistan, United States soldiers gather near a destroyed vehicle, and protect their faces from rotor wash, as their wounded comrades are airlifted by a Medevac helicopter from the 159th Brigade Task Force Thunder to Kandahar Hospital Role 3, on August 23. Three soldiers are wounded when their vehicle is destroyed by an improvised explosive device. The fighting against Taliban insurgents in and around Kandahar remains fierce all year.

Hostage

On September 6, a man throws a piece of paper through broken glass during a standoff in the Parramatta neighborhood of Sydney, Australia. It is the kind of story that travels the world in an instant these days: Embroiled in a custody suit, the man had entered a law office with his 12-year-old daughter, claiming to have a backpack with a bomb. An 11-hour hostage situation followed, with law enforcement, hostage negotiators and bomb squads responding. Police eventually broke in, arrested the man and freed the girl.

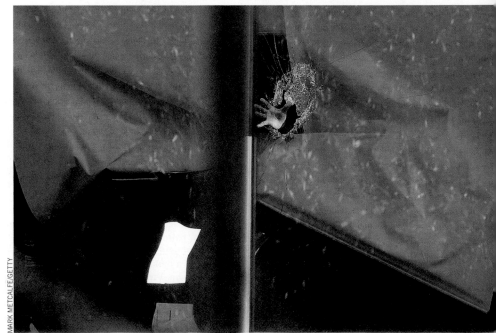

MARK METCALFE/GETTY

Cop Down

German Township Patrolman Jeremy Blum is wounded in a police shootout with a gunman at Enon Beach trailer park near Enon, Ohio. Blum is shot in the arm and shoulder; he will recover. His colleague, Suzanne Hopper, a 40-year-old mother of two, is killed during the altercation, as is the gunman. This, as with the kidnapping in Australia, rivets an online audience from dawn to dusk as details—and new photographs—emerge. LIFE magazine once redefined photojournalism, and today LIFE.com understands how the newest form is best practiced.

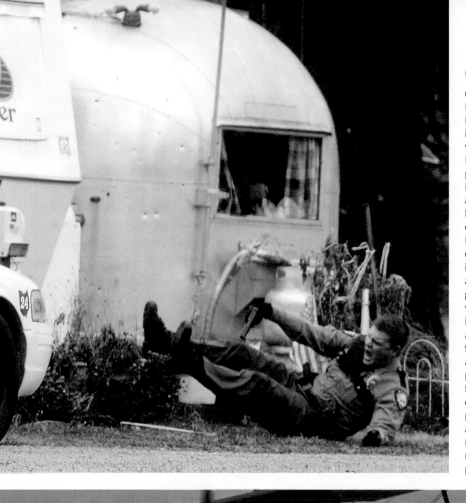

MARSHALL GORBY/SPRINGFIELD NEWS-SUN/AP

JOHANNES EISELE/AFP/GETTY

Horrific

Wing walker Todd Green falls to his death after losing his grip performing a stunt during an air show at Selfridge Air National Guard Base in Harrison Township, Michigan, on Sunday, August 21. Green was trying to move from the plane to a helicopter before he fell. LIFE has never looked away: not during World War II, not during Vietnam, not during the civil rights era, not during 9/11 and not during the day-to-day tragedies that beset us.

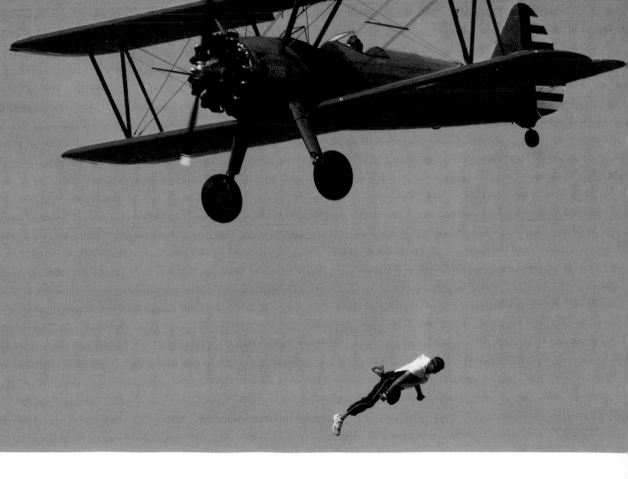

DAVID ANGELL/MACOMB DAILY/AP

Cute as Can Be

If the photos on the previous two pages were "tough" or "difficult," LIFE.com also presents many images intended to elicit a smile. Here, a cross-eyed opossum named Heidi makes a face in the zoo in Leipzig, Germany. This is just the kind of picture that has the potential to, as they say, go viral. "Pictures of the Week is a consistently big draw with our Friday morning audience," says Barnett. "And then it gathers momentum with iPad and other tablet users getting to see the photographs at their stunning best through the weekend."

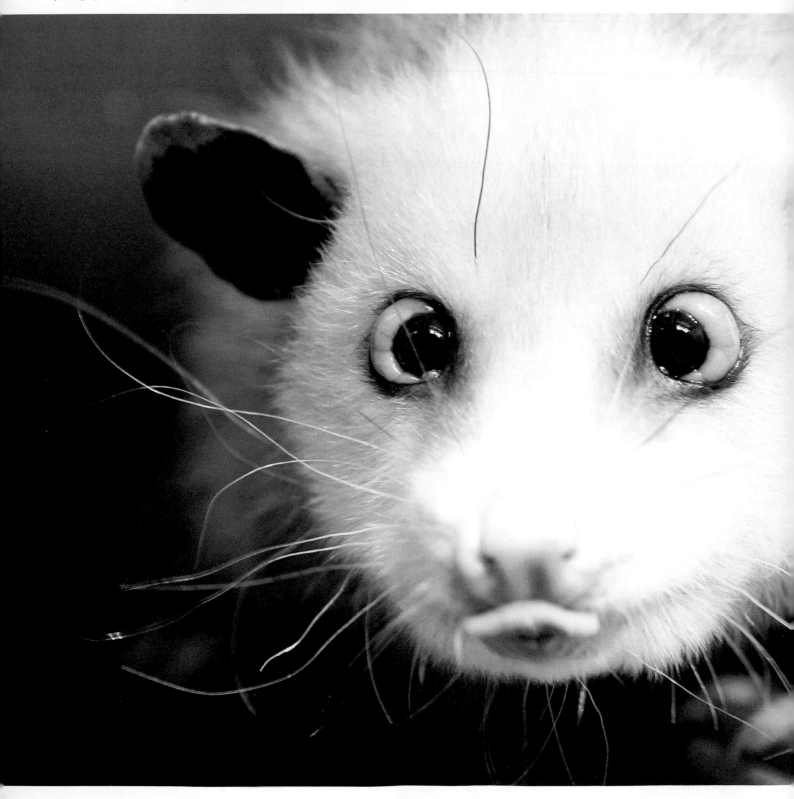

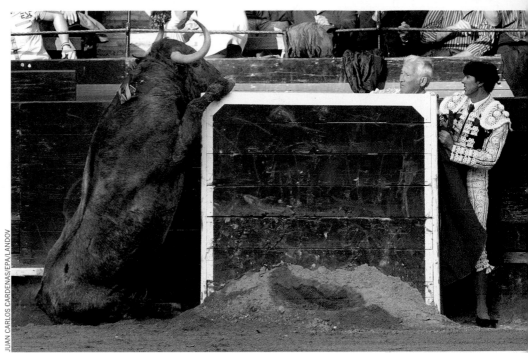

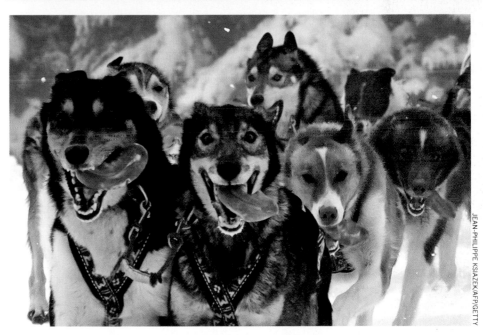

He's Had Quite Enough

Top: A bull tries to jump the barrier in his unfair contest with matador Alberto Aguilar during a bullfight at the Fallas Fair in Valencia, eastern Spain, on March 20. The sport becomes a controversy anew this year, and will be banned in parts of Spain's Catalonian region beginning in 2012. Photos like this help people make up their minds on issues from international politics to animal rights. "In balance, a week's work is fascinating, moving and never, ever dull," says Barnett of his Pictures of the Week assignment. "Photojournalism for me is an effective and wonderful way to learn, and to travel—virtually—and make oneself be aware of the issues of the day."

Not the Iditarod

An American confronting a picture such as the one above would assume he or she is visiting Alaska, but LIFE.com goes further. On January 10 in Praz sur Arly, a town high in the Rhône-Alpes region of southeastern France, these sled dogs are more than eager during the fourth stage of the Grande Odyssée, an 11-day race through the mountains covering some 620 miles that is, this year, in its seventh edition. A photograph such as this will instantly separate itself from the pack for LIFE.com's editors. "People ask me what I do and I tell them I look at pictures all day," says Barnett. "And yes, that is as good as it sounds. What could be a better way to ply a trade?"

Summer

End of an Era

Farewell to the Space Shuttle! Begun in 1981 with the launch of STS-1 on April 12 (20 years to the day after Soviet cosmonaut Yuri Gagarin had become the first human being in space), STS-135 was sent on its way to the International Space Station on July 8 (here, a U.S. Air Force Strike Eagle patrols the skies above NASA's Kennedy Space Center in Orlando, Florida, as the orbiter *Atlantis* is launched). It would return on the 21st, and then be retired. Five spacecraft were used during the three-decade Shuttle program: *Columbia* (the first to fly, with John Young and Robert Crippen aboard), *Challenger*, *Discovery*, *Atlantis* and *Endeavour*. The Shuttle was the world's first reusable spacecraft—it returned to earth like a giant glider—and had an illustrious history, dotted with tragedy. Sally Ride became the first American woman (and youngest American, at 32) in space in 1983, and in 1998 the legendary John Glenn, first American to ever orbit the planet, returned to space aboard *Discovery* (becoming, at 77, the oldest person ever to exit the atmosphere). Astronauts floated free outside the Shuttle, working repairs on the orbiting Hubble telescope, and brought parts, other resources and scientists to the Space Station. Of course, two Shuttles exploded, the *Challenger* shortly after liftoff in 1986 and the *Columbia* upon reentry in 2003, and those shocking incidents are more indelible in the American mind-set than any Shuttle triumphs. Nevertheless, the Shuttle broadened our view of the world, and our expectations of what is possible.

Boys Behaving Badly

When the flowers bloom in springtime, the time is ripe for a love story. Not this kind, however: three separate escapades involving prominent political men whose revealed activities dominated the gossip pages throughout the season. On May 9, after 25 years of marriage, Arnold Schwarzenegger (right) announces that he and his wife, Maria Shriver, are separating. A week later, he admits to having fathered a child with a former member of the household staff. On May 14, Dominique Strauss-Kahn (below) is arrested at John F. Kennedy Airport in New York City on charges of sexually assaulting a hotel maid. Three months later, the case against the former director of the International Monetary Fund is dropped, and a month after that, Strauss-Kahn says that the sexual encounter was a personal mistake, though not a criminal act. On June 16, U.S. congressman Anthony Weiner (opposite) resigns after admitting that he tweeted a photo of himself in his underwear to a young woman. Jokes playing off "Weiner" (it's not pronounced "whiner") seem simply too easy for the late-night TV mafia, which doesn't deter them one whit. In September, Weiner's vacated seat is won by Bob Turner, who becomes the first Republican to represent New York's Ninth Congressional District since 1920: real world ramifications to Page Six sport.

July 4 During the year, **bacteria and virus outbreaks** will plague the world. On this day, a virulent strain of E. coli that infected more than 3,900 people in Germany and killed 42 as it swept through Europe in May, is finally quashed. The rare form of bacteria called O104:H4 was spread through bean sprouts. Listeria is yet to make news in the U.S., but it will in late summer and early autumn.

July 4 *The Guardian* in London breaks the story that the *News of the World,* owned by Rupert Murdoch's News Corporation, hacked into the cell phone of a British schoolgirl who was missing at the time and was later found murdered. This sets off a maelstrom within the long-gestating phone hacking investigation directed at *News of the World* journalists. Ultimately, the British tabloid closes and **the bruised Murdoch** withdraws a $12 billion bid to take over Britain's biggest satellite broadcaster—realizing the sale won't be approved if he pushes the measure.

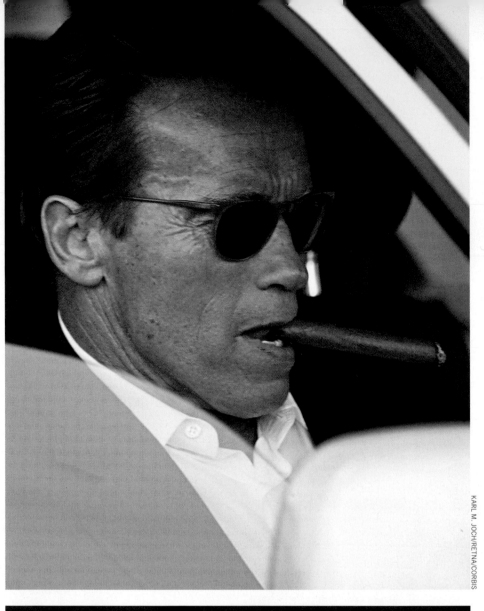

KARL M. JOCH/RETNA/CORBIS

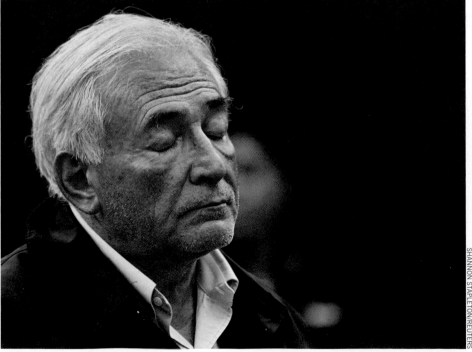

DENNIS VAN TINE/RETNA/CORBIS · SHANNON STAPLETON/REUTERS

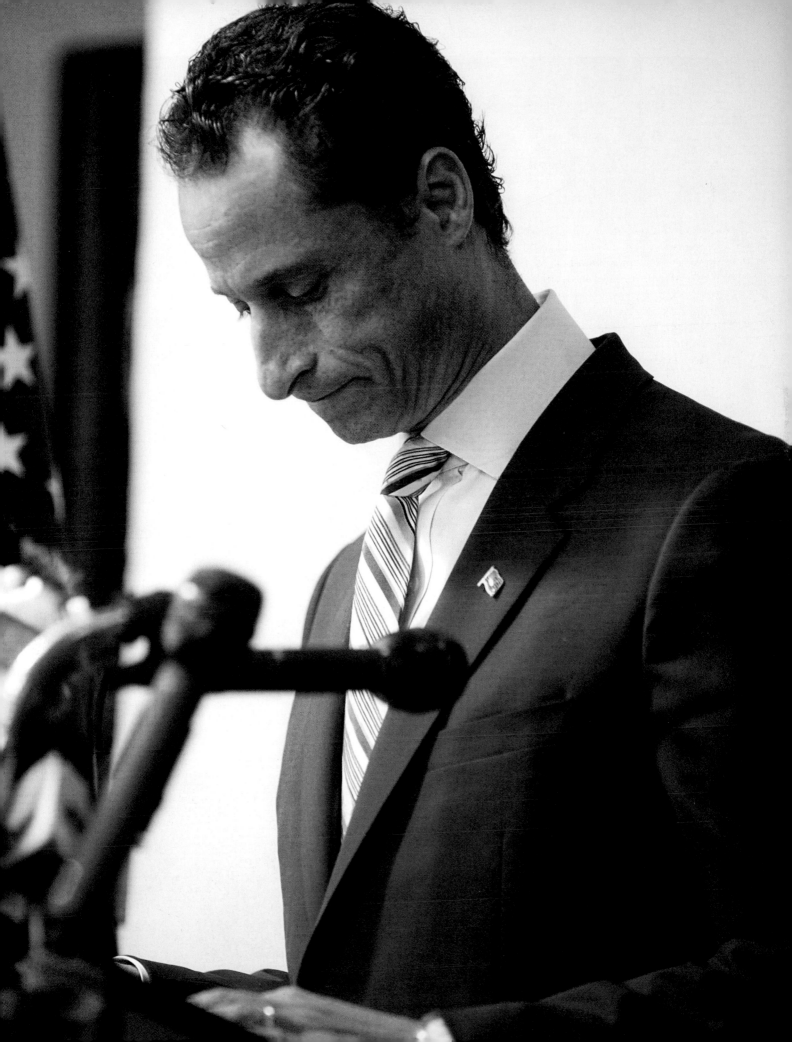

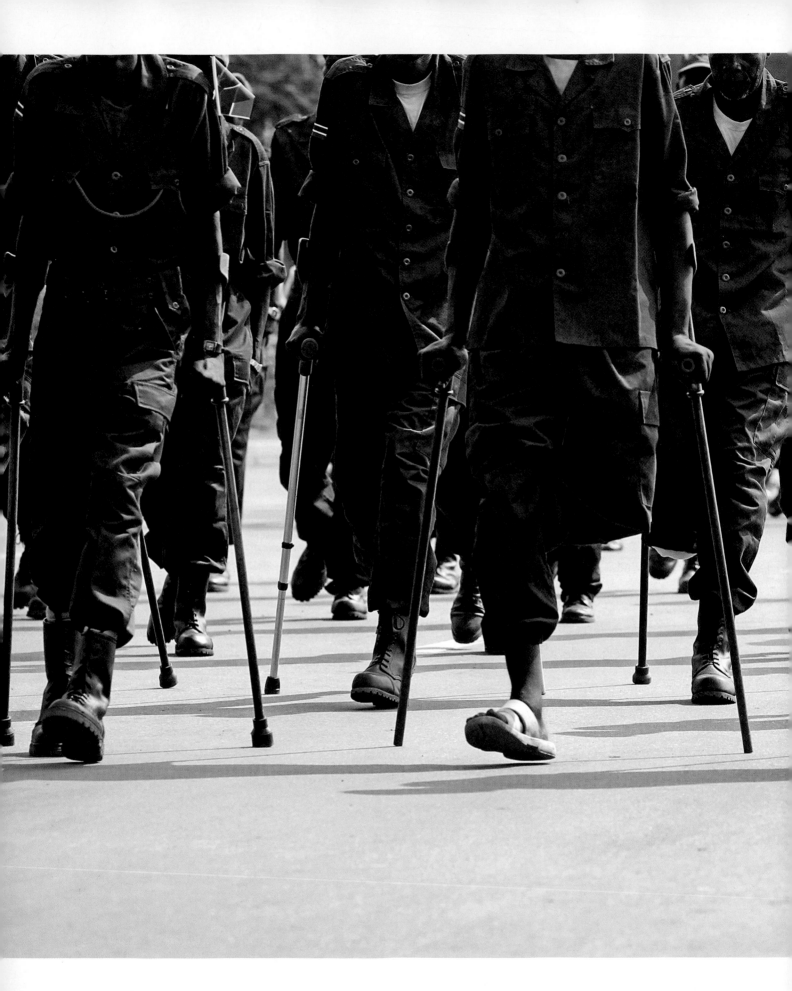

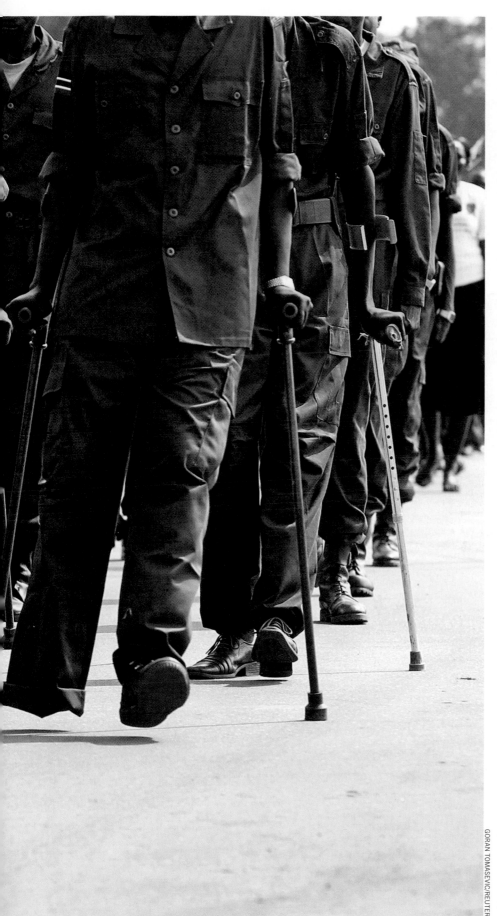

Sovereignty, at a Cost to All

On July 5, wounded Sudan People's Liberation Army (SPLA) veterans march in Juba during a rehearsal for the upcoming Independence Day ceremony. South Sudan indeed becomes a sovereign state on July 9, and not long after joins the United Nations and the African Union; additionally, it sees U.S. sanctions, which will remain in place against Sudan itself, lifted. South Sudan needs its new friends, as it is one of the world's poorest nations, with a health situation that can be described as dire in the extreme. So far, of course, what you have seen here and read garners support and sympathy—amputees, "liberation," "independence," acceptance by the U.N., a population in desperate need—and for many South Sudanese citizens, it should. But what of these soldiers, and how did their side come to power? The SPLA stands accused of having committed the most horrific atrocities in recent years, burning villages to put down rebellions (South Sudan's states remain involved in a half dozen civil wars), torturing hundreds, raping untold numbers of women and girls, killing unarmed civilians. In May of this year the army allegedly burned more than 7,000 homes in the poignantly named Unity State. The United States, for its part, is well aware of all this, of course, and although Washington has reached out to the fledgling country of South Sudan, the U.S. Intelligence Community has not withdrawn its warning, first made in 2010, that in the next few years "a new mass killing or genocide is most likely to occur in southern Sudan." On the day of a parade there is always optimism. Then follows the hard business of the future.

July 4 Sting cancels a concert in Astana, the capital of Kazakhstan, to show his support for several thousand oil and gas workers who have been on strike since May 26. The strike is part of a larger movement of labor unrest in the former Soviet republic. Kazakhstani industry is unmoved by **Sting's gesture**. Little or nothing changes.

July 5 Casey Anthony, the Florida woman accused of abusing and murdering her two-year-old daughter, is acquitted of those charges in the so-called **Social Media Trial of the Century**, while found guilty on four counts of lying. In 2008, Anthony waited weeks to report her daughter missing, and then misled investigators during their investigations. After the court has spoken, society's jury remains out on Casey Anthony, and how Caylee Anthony died remains a mystery.

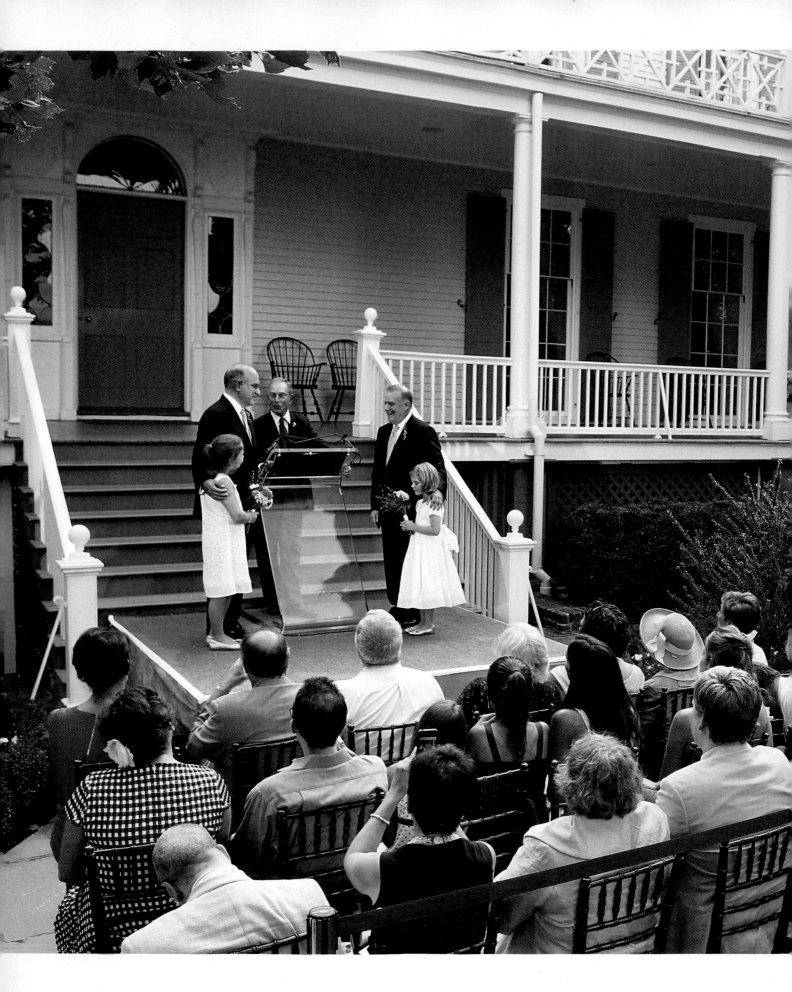

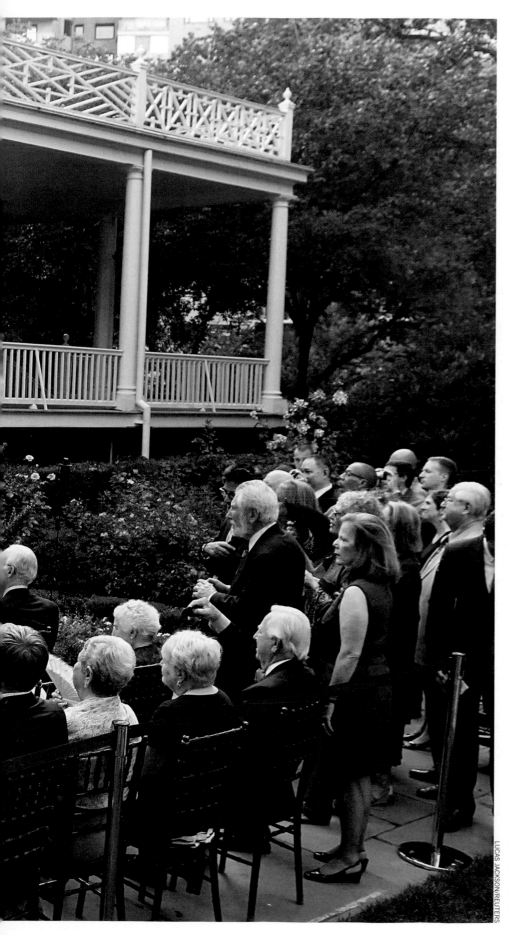

"I Do!"

Jonathan Mintz, left, New York City's consumer affairs commissioner, and John Feinblatt, a chief advisor to the mayor, stand with daughters Maeve (with Mintz) and Georgia as they are married by their boss, Michael Bloomberg, at the official mayoral residence, Gracie Mansion, on the Upper East Side of Manhattan on July 24, 2011. It is a beautiful day and a beautiful weekend for thousands of gay and lesbian New Yorkers as they take advantage of the fact that the Empire State has, just now, become the sixth in the U.S. to embrace same-sex marriage. In a banner year for the gay-rights movement, the military's "don't ask, don't tell" policy, which since 1993 had prohibited discrimination against closeted homosexual service personnel while nonetheless barring openly gay, lesbian or bisexual people from serving at all, will be officially ended by summer's end. Of course, legislative initiatives rarely make an issue go away. Gay marriage will certainly be a hot-button topic in the election year, as will gays in the military. When, during a Republican presidential debate in Florida in October, a gay soldier on active duty in Iraq asks whether the candidates would seek to roll back the September 20 decision, which had been supported by the Joint Chiefs of Staff as well as the Commander in Chief, he is booed by the partisan crowd.

July 5 The son of Georgian president Mikheil Saakashvili sets a Guinness World Record for **typing the English alphabet** with his right hand on an iPad in only 5.26 seconds. Fifteen-year-old Eduard Saakashvili says he prepared for months, and ultimately shaved 1.05 seconds off the previous record, which had been set by a British teen in 2010.

July 24 Cadel Evans becomes the first Australian to win the Tour de France. The 34-year-old, who has been riding since he was two, celebrates his historic feat by donning **the victorious yellow jersey** and cruising down the Champs-Élysées with a glass of champagne. Cycling fans point—hopefully, desperately—to Evans's unique provenance and historically unsensational progress through the mountains as evidence that this year's race was "clean"—i.e., devoid of the performance-enhancing drugs or illegal procedures that have plagued their sport.

Her Big Bathtub

This lovely fraulein is lounging in Alster Lake in Hamburg, Germany, on August 3. The sculpture, a dozen feet high above water level and the creation of Oliver Voss, is one of those summer frivolities that bring a smile during the dog days, and are disassembled well before the leaves turn color. Which isn't to say the lady of the lake was to everyone's taste. Lest Americans fear that, in 2011, ours was the only nation to argue about every little thing, be assured that this very temporary display of pop art created quite a stir. Voss said that his aim was to create "a topic of conversation in Germany," and he sure did so, with the district mayor, Markus Schreiber, charging that the bathing beauty was "sullying the beloved lake." Voss countered: "Hamburg and the water belong together. People live by, and from, the water. My team and I wanted to demonstrate this relationship in a fun and entertaining way. We also hope she will encourage more people to rediscover and experience our city by the water. After all, if the Inner Alster is the living room of Hamburg, of course someone should make themselves comfortable in it." Anyway, the lady's quick bath lasted only 10 days, as planned, and then she dried off. German officials relaxed, happy to return to less pressing matters, like whether to bail out the Greek economy.

July 27 A riot breaks out among revelers and moviegoers at the Los Angeles premiere of *Electric Daisy Carnival Experience.* Why? Well, DJ Kaskade, who is featured in the film, has tweeted that he will be spinning at **a free block party** outside the invite-only premiere, and within hours, the L.A. police department is forced to shut down Hollywood Boulevard in reaction to the human traffic jam and reported violence and vandalism. This is just the latest sign that the apocalypse is upon us, or that everything is happening—and will happen—instantly in the brave new world.

August 1 Foxconn Technology Group, a Taiwanese company that assembles iPhones and iPads in China, says it will increase the number of robots in its labor sector to as many as one million by 2013, while shifting its *human* employees "higher up the value chain." (They were already higher up the food chain.) Worker morale among the sentient at Foxconn had cratered in the last several years, so much so that nets were erected around the building to catch suicide jumpers. **The robots are reportedly content** with the new plans. For now.

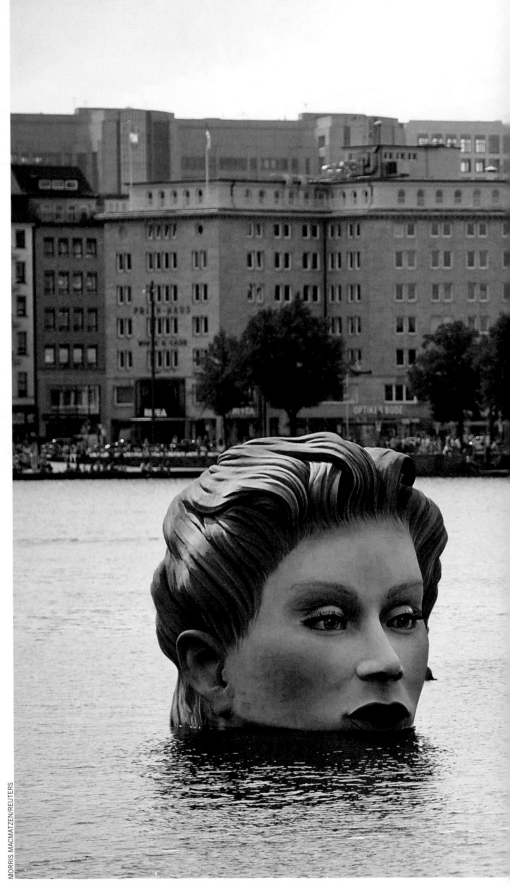

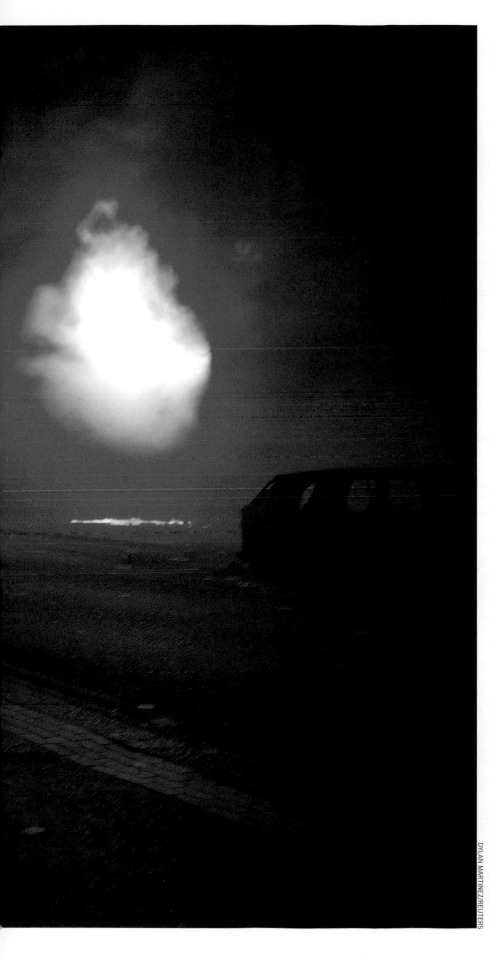

DYLAN MARTINEZ/REUTERS

London Burning

Discounting the violence in Northern Ireland in years past, it was the worst domestic unrest in Britain in decades. In early August, London exploded, with hooded youths setting buildings and cars ablaze, looting stores, clashing with police on seemingly every street corner in the poorer sections of precincts such as Croydon (where, here, a fire engulfs shops and residential properties on August 9, the fourth day of demonstrations). The violence seemed as if it had been ignited by, and was playing out to, an old Clash song, but in fact the catalyst had been the killing of 29-year-old father of three Mark Duggan by police during an attempted arrest on August 4 in Tottenham. The law had been watching Duggan, wary that he might be plotting a revenge attack for an earlier murder. The first riot was in Tottenham, and the wave moved outward, even beyond London to other major English cities. General endemic grievances were attached to the protests that had little to do with Duggan's case—unemployment, disenfranchisement, basic social inequities—while British authority figures started wondering about a modern society gone to hell. Beyond the philosophical arguments, five people died, 16 were injured, £200 million worth of property was damaged, 3,443 crimes were committed in London, and 3,100 people were arrested before the riots were quelled in mid-August.

August 2 Scientists announce that they have discovered the skull of **a tree-climbing herbivore ape** in Uganda's Karamoja region. This is the first time a skull of this age—20 million years old—has been found completely intact. By way of contrast, the famous skeleton found in Ethiopia in 1974 of Lucy, an upright walking hominid, was dated at 3.2 million years, and that of an even earlier hominid, Ardi, discovered in 1994 also in Africa, was 4.4 million years old.

August 4 A new 10-year labor agreement ratified by a majority of NFL players includes **blood testing for human growth hormone (HGH)**, which begins in September when the new season launches. The agreement has been more than three years in the making, and marks the first time a major American sports league has implemented HGH testing with the agreement of its players' union.

August 8 Following Standard & Poor's downgrade of the United States' credit rating, **Wall Street hits its lowest point** since the 2008 financial crisis with the Dow Jones plunging below 11,000. The New York Stock Exchange trades a whopping 18 billion shares on this day, the most active of the year so far.

The Whales' Tale

On August 11 snorkelers swim with a 20-foot whale shark just outside Hanifaru Bay off the Maldive Islands' remote Baa Atoll. Every May, the plankton in this geologically unique harbor begin to bloom, and by midsummer there is a daily feeding frenzy among whale sharks and giant manta rays. In recent years, tourists and underwater photographers have become aware of this. So what you have come August is a small bay about the size of a football field, 200 mantas, scores of whale sharks and bunches of human beings. If that sounds to you like a recipe for ecological or other disaster, many Maldivian authorities would agree, and the plan is to shut down the bay to this kind of recreation. The plankton will continue to bloom in their cycle, the rays and sharks will continue to dine, but they will do so largely in the privacy of their own home.

August 8 Philadelphia mayor Michael Nutter signs an order setting curfews on weekend nights for those under the age of 18. In the past two years, the city has seen **"flash mobs"** of young people, as many as thousands at a time, gather via text messages and social media to harass and assault people, in one case descending en masse on the restaurant district and causing several establishments to close for the night.

August 25 Curtis Granderson, center fielder for the New York Yankees, hits a grand slam in the bottom of the eighth inning, which follows two earlier grand slams by teammates Robinson Cano and Russell Martin. **The Yankees** not only win 22—9 against the Oakland Athletics this night, but they **make history** for being the only major league team ever to smash three in a game. All good, but it won't help in the postseason, where the Yanks will be ousted by the Detroit Tigers, who in turn will fall to the Texas Rangers.

August 28 After singing "Love on Top" at the 2011 Video Music Awards, Beyoncé makes a *dramatic* (by pop standards) announcement onstage to fans and friends alike by unbuttoning her blazer and **showing off her baby bump**. Proud hubby and father Jay-Z grins from the audience while the Nokia Theatre erupts in applause. It's not clear if the baby-to-be will be given a last name or just an instantly famous trademark.

September 4 Back on the Fourth of July, Joey "Jaws" Chestnut, the chowhound currently ranked tops by the International Federation of Competitive Eating (yes, really), probably thought he had stolen all the year's gluttony headlines when he won his fifth straight Nathan's Hot Dog Eating Contest, downing 62 weiners in 10 minutes. But no. On the far end of summer vacation, Sonya Thomas, known as the "Black Widow" for **her ability to out-eat men**, wins the U.S. Chicken Wing Eating Championship upstate in Buffalo, also for the fifth year in a row. The svelte Thomas bests her own record by consuming 183 wings in 12 minutes. She cites stomach capacity, jaw strength and hand speed as key attributes in competitive eating. Sounds right.

The American Game, Modern Day

Every summer Little Leaguers from around the world, who started swinging and pitching in spring and even earlier, convene in Williamsport, Pennsylvania, for their world series tournament. The American teams compete against each other in one bracket, their winner to vie against the foreign winner from the other side of the draw. In recent years, the final game has often been a toss-up, as baseball long ago was exported to Asia, Mexico, the Caribbean and elsewhere; in many of these places, the sport rivals football (read "soccer") as a national pastime. This year, the Little League World Series was particularly captivating as a Pennsylvania team made it deep into the tournament, and thousands of home-state fans who couldn't score tickets filled the hillside beyond the bleachers. The boys from PA were eventually eliminated, and a spunky bunch from Huntington Beach, California, met the lads from Hamamatsu, Japan, in the championship, with Hamamatsu hoping to defend a title won last year by a Tokyo team. In latest August, after the outer bands of Hurricane Irene caused a three-hour-plus rain delay, the kids got down to it, and with two outs and the bases loaded in the final inning, the California manager's son drilled a single that sent across the winning run in a 2–1 victory. In the American way of looking at things, the trophy was coming *home*—as this Norman Rockwell–worthy towhead shouts to the world.

September 4 Following surgery and buoyed by the support of hundreds of onlookers, the emperor penguin nicknamed **Happy Feet** is released into the Southern Ocean of New Zealand to begin its 1,860-mile swim home to Antarctica. Three months earlier, in June, Happy Feet had washed up on Peka Peka Beach with six pounds of sand in its stomach, which researchers believe the bird had mistakenly consumed thinking it was snow.

September 18 Sixteen-year-old **Lexi Thompson**, who four years earlier had become the youngest girl ever to qualify for golf's U.S. Women's Open and who at 15 turned pro, nabs a five-stroke victory at the Navistar LPGA Classic, becoming the youngest golfer to win a women's pro golf tour event. The high school junior waits to hear if she will be exempted from the LPGA's 18-year-old age requirement so that she can compete on the tour next year, and in the meantime goes to a Blink-182 concert with friends. On September 30 comes the good news: She's been granted her exemption.

TIM SHAFFER/REUTERS

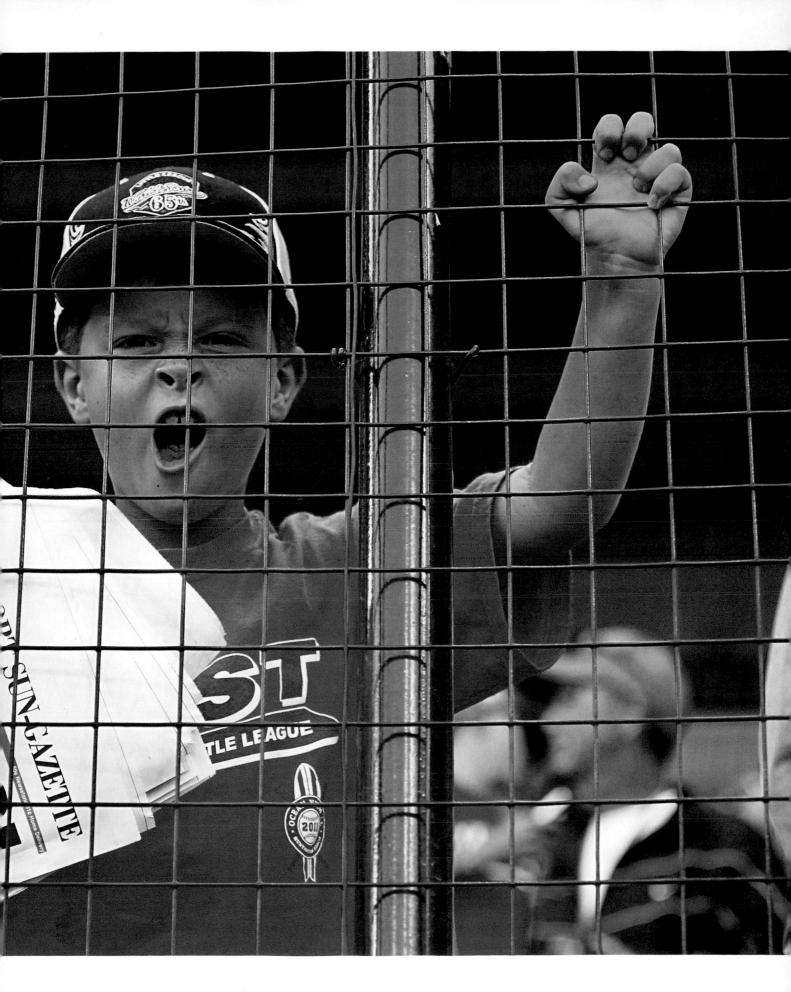

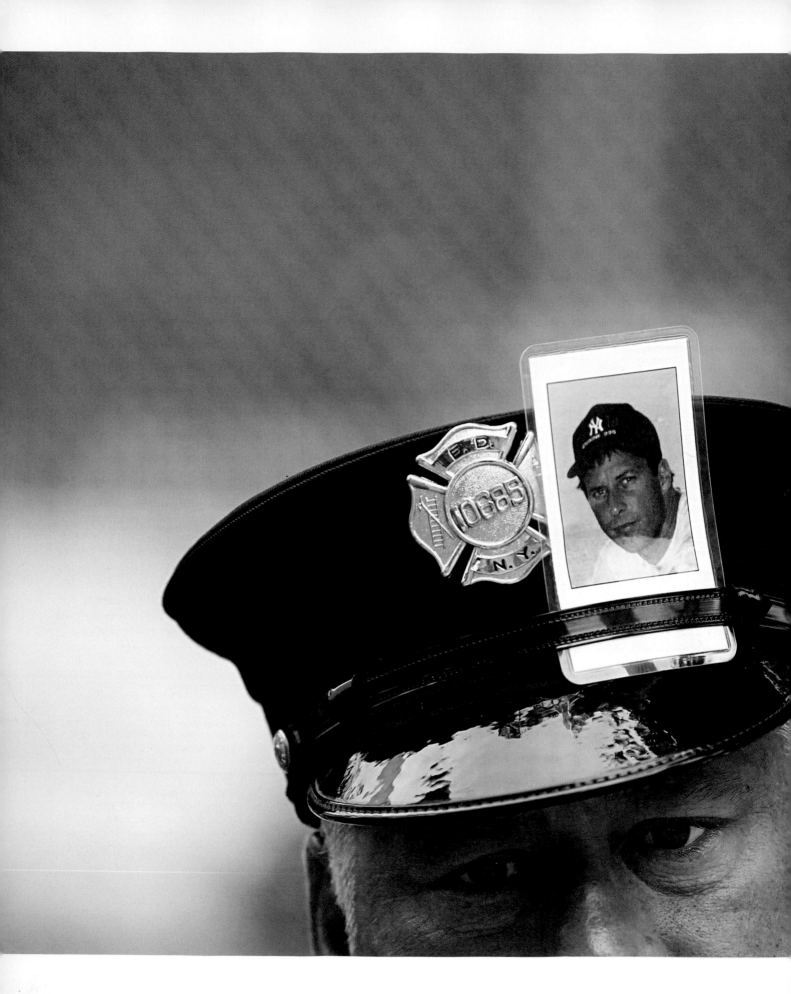

Remembrance

Everyone was well aware that it was approaching: the tenth anniversary of the attacks of 9/11. The President's itinerary had been planned, as had those of his predecessor, George W. Bush, of former mayor Rudolph Giuliani, of a thousand cops and firefighters. Many, many commemorations were planned: in New York City; in Shanksville, Pennsylvania; in Washington, D.C.; in London and Paris; everywhere. Security was heightened, but in the event there were no violent aftershocks from a decade ago. There was, rather, reflection and remembrance. We remembered what had happened, and all that has happened since in our confusing world. We reflected on what it all meant. We did not exactly revisit the time—that would have been impossible. But those closest to the events recalled those who were lost, and as the names of the deceased were read aloud in a variety of venues—the long recitation in New York took on the rhythms of a hymn—it became clear that they, the victims, represented the soul of this day, 10 years on. In this photograph, one of New York City's bravest attends ceremonies at the World Trade Center site on September 11. The image in his cap is of Brian McAleese, his fallen fellow firefighter, who died precisely a decade ago at age 36, leaving behind a wife, four kids, age five and younger, and a world of close friends.

September 18 In Buffalo, New York, 14-year-old Jamey Rodemeyer is found dead outside his home. The gay teen had been **relentlessly tormented by classmates** over his sexuality, and committed suicide after posting an online farewell. His death puts a spotlight on cyberbullying and, a month later, inspires actor Zachary Quinto of *Star Trek* fame to come out publicly as gay.

September 20 Pakistan's national disaster authority says that at least 361 people have died and 600,000 are living in refugee camps because of **massive flooding from monsoon rains** throughout the country's southern provinces. This is a double hit for a region still struggling to recover from last year's floods, which left 20 percent of the country underwater.

September 20 After eight years, Wadah Khanfar steps down as head of the **al-Jazeera satellite TV network** and is replaced by Sheikh Ahmed bin Jassim al-Thani, a Qatari royal. Khanfar is a Palestinian-born journalist credited with making al-Jazeera a force by fighting the routine censorship expected in all Middle East broadcasting.

The Attacks in Norway

Below: On a sunny July 21 on Utoya island, dozens of young people enjoy their day at summer camp—a camp sponsored by a political party, yes, but still just a camp. Below, right: Members of Norwegian Special Forces land by boat on the shore of the island the following day. There has, earlier, been a bomb attack in Oslo, multiple shootings out here in this idyllic setting, and all is now chaos. Gone forever: the idea that "this kind of thing doesn't happen in Norway."

There are phrases that equate instantly with notions of youth and innocence. *Playdate. Ice cream with sprinkles. Sandlot baseball. Sleepover. Summer camp.*

This is why the dual attacks in Norway on July 22 not only stunned the wider world awake, but lingered for days as we all tried to sort it out: What had happened? What was this about?

Why, in God's name, why?

The facts of the matter: At 3:26 a.m. a car bomb exploded in the government district of the Norwegian capital, Oslo. Eight people were killed, 10 were critically wounded and several others were injured. Ninety minutes later, a man disguised in a police uniform and possessing a false I.D. boarded a ferry about 20 miles northwest of the city, and was granted access to an island called Utoya—an island being principally used at the time as a youth camp. He was, we now know, the same man who had planted the bomb, and soon he opened fire with an automatic weapon, sometimes tempting campers closer as if their protector, then chasing others into the water as they fled. His name was Anders Behring Breivik, and he killed 68 adolescents and adults on the island. *Sixty-eight*, which in a country like Norway—or anywhere, frankly—is a stunning number. Friends of the nation's prime minister died, as did the stepbrother of the crown princess. And so many kids, their futures denied.

What had happened? What was this about? Why, in God's name, why?

As the case unfolded, Breivik was revealed to be a fanatical right-wing political extremist. For years he had been a presence on the Internet, railing against Muslims and his nation's immigration policies, which he saw as terribly lax.

But still: Why would anyone target young people at a summer camp? There emerged a (certainly indefensible) reason: The camp was run by the youth division of the currently ruling Norwegian Labor Party. In Breivik's thinking, his Oslo bombing and the Utoya shooting spree were of a piece.

So this was, as others have said, not Norway's 9/11 but

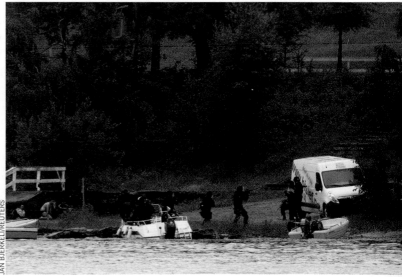

JAN BJERKELI/REUTERS

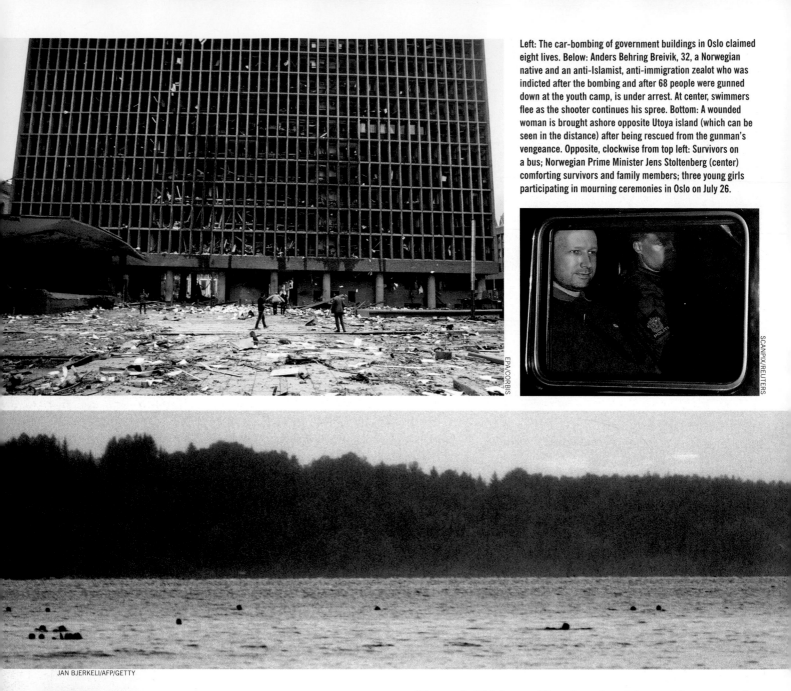

Left: The car-bombing of government buildings in Oslo claimed eight lives. Below: Anders Behring Breivik, 32, a Norwegian native and an anti-Islamist, anti-immigration zealot who was indicted after the bombing and after 68 people were gunned down at the youth camp, is under arrest. At center, swimmers flee as the shooter continues his spree. Bottom: A wounded woman is brought ashore opposite Utoya island (which can be seen in the distance) after being rescued from the gunman's vengeance. Opposite, clockwise from top left: Survivors on a bus; Norwegian Prime Minister Jens Stoltenberg (center) comforting survivors and family members; three young girls participating in mourning ceremonies in Oslo on July 26.

EPA/CORBIS

SCANPIX/REUTERS

JAN BJERKELI/AFP/GETTY

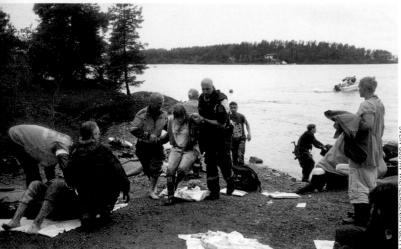

SVEIN GUSTAV WILHELMSEN/AFP/GETTY

Norway's Oklahoma City: A native citizen with a complaint had claimed the lives of scores of people in a certainly futile attempt to forward his agenda. He had carefully plotted his attacks, and knew that his many victims would include the young and innocent. Anders Behring Breivik and Timothy McVeigh were the same person, separated by an ocean and a decade, McVeigh having been executed 10 years and 41 days before Breivik went on his rampage.

The takeaway from the attacks in Norway was quite different than that of the 2011 assassination attempt on Gabrielle Giffords. In the U.S., as we have written earlier (please see page 26), there had been a general sense of relief that Giffords's shooter might simply have been insane. Norway made all of us ask anew, as we have asked many times in recent years (especially in the 10 years since 9/11): *What is this world we are living in?*

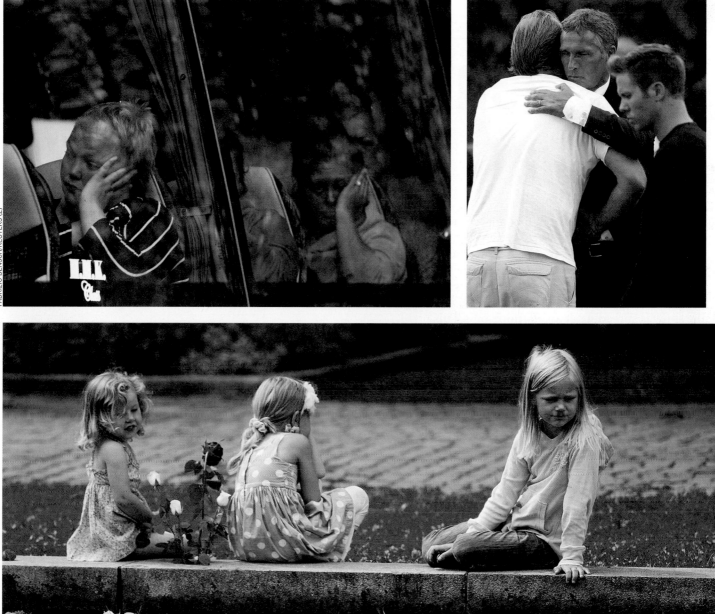

PORTRAIT
President Obama

One thing we know for certain: He doesn't use Just for Men or Grecian Formula. Barack Obama is wearing, perhaps proudly, the trials of the last three years on his pate. He's still trim and often smiling, but the snow is spreading at an alarming rate. This reflects, certainly, the alarming times we live in, and the alarming year he has just weathered as the leader of the free world.

The past many months have had ups, downs and all-arounds. Before the going got serious, there was silliness. The so-called "birthers" who persistently challenged Obama's presidential legitimacy, claiming he might have been born elsewhere than Hawaii (Kenya most often cited) and that therefore he should have been constitutionally ineligible to even run for our highest office, found an unlikely champion in the curiously coifed posturer Donald Trump, when he briefly floated his own presidential aspirations, a trial balloon that, as we've noted earlier (page

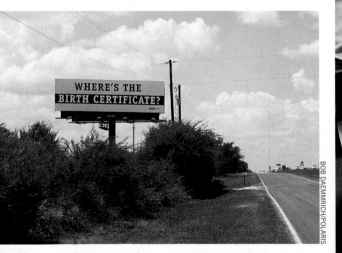

The President's year of silliness and seriousness: Whether he was a real American consumed conspiracy theorists to the point that they spent money on billboards, like the one above in Waco, Texas. Right: On May 1 in the White House, President Obama and his innermost team gather to watch in real time as Osama bin Laden is taken out in Pakistan (already May 2, there).

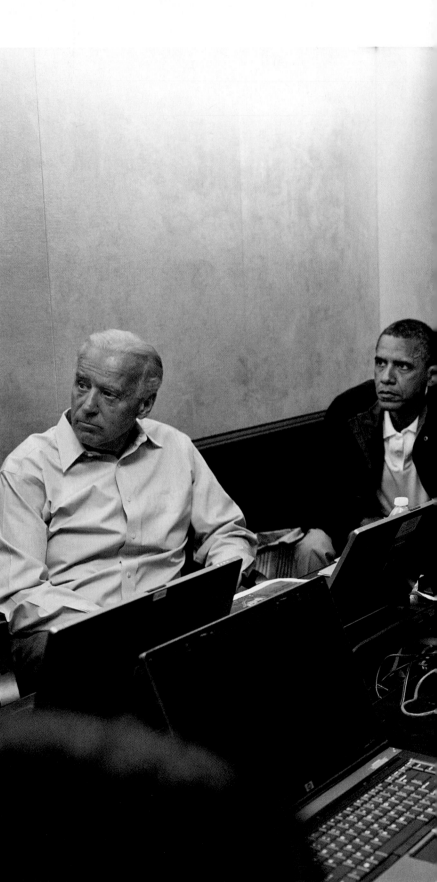

BOB DAEMMRICH/POLARIS

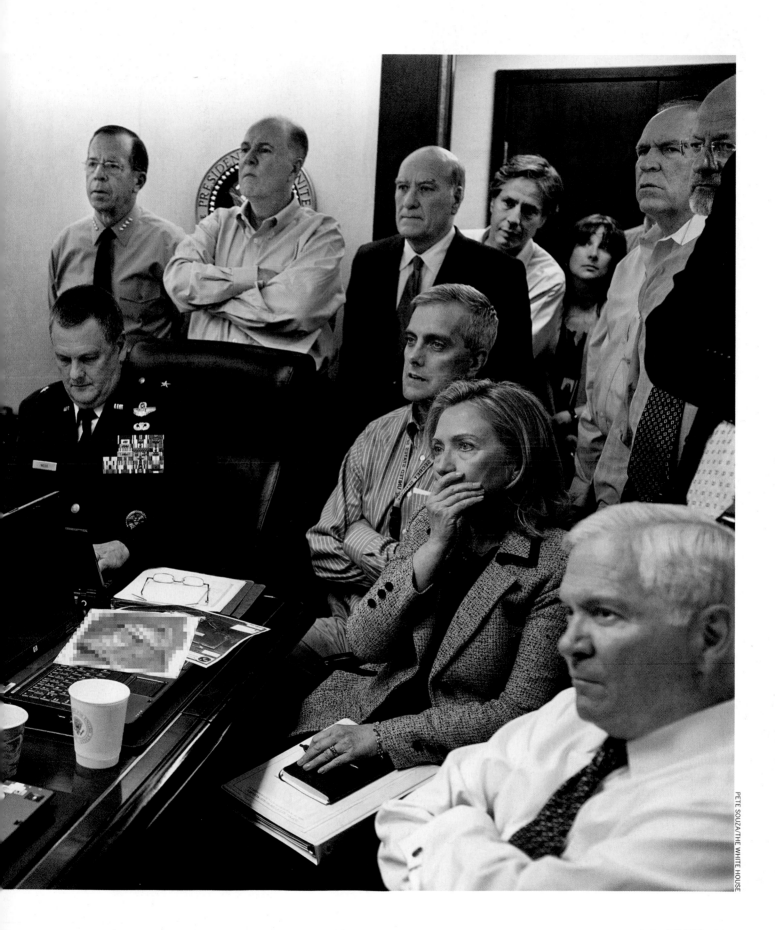

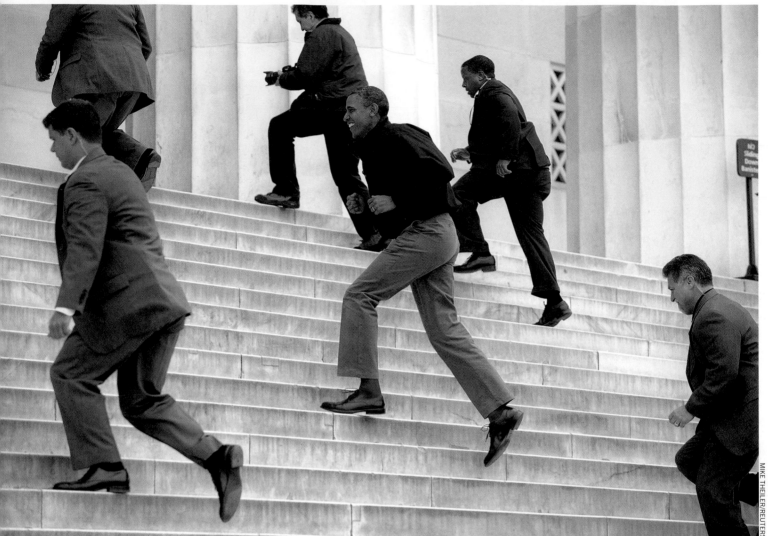

22) quickly burst. The White House released Obama's so-called "long-form birth certificate" in April, and old newspaper accounts of his Hawaiian birth were unearthed, but still millions of adult Americans persisted in their drumbeat of doubt (even as "the Donald" finally caved, while of course claiming credit for the conclusive paper trail).

On May 2, Osama bin Laden was finally brought to justice during a daring raid by Navy Seals on a compound in Pakistan, and the President's courage and composure in authorizing and helping to direct the mission were saluted by all his countrymen, regardless of political persuasion. The revivifying nonpartisanship, and attendant rise in the President's popularity, lasted for one or two news cycles, and by summer, his approval rating seemed inextricably tied to economic trends and jobs reports—which is to say, it was pointing downward. The President seemed, some weeks, to have no friends at all, with members of his own party wondering aloud if his stimulus package had been large enough, while the Republican attack coalesced around the idea of a "zero" presidency. Obama could and did break bread (and play some golf) with Speaker of the House John Boehner, the opposition's leading legislator, but civility ended when

At top, Obama bounds the steps of the Lincoln Memorial to tell tourists that Congress's agreement on funding the federal government will keep national parks and monuments open, but much more turmoil is ahead. Above: He and House Speaker John Boehner chat amiably on a patio outside the Oval Office on July 3, but the country's partisan divide proves intractable. Opposite, top left: World markets (this one in Germany on August 8) cause tension all year. Right: The President enjoys a happy moment while visiting—not "campaigning"—in Chatfield, Minnesota, on August 15. Bottom: On 9/11, with his wife, Michelle, and former President George W. Bush, in New York City.

the last putt dropped, and gridlock in Washington made L.A. freeways seem like smooth sailing. Particularly in the run-up year to a general election, and with the Tea Party flexing its muscles, any Republican who so much as hinted at compromise or collegiality was seen as treasonous.

Obama tried to take his message on the road, traveling to the Midwest in August and insisting that his constituents hold their representatives accountable for the calcification of the political process and for the ruthless brinksmanship that had caused the recent debt-ceiling dustup, a contretemps that had injured America's reputation with other nations and with at least one prominent economic ratings agency. He was preaching largely to the choir during that

bus tour, and yet there was an unavoidable sense that the White House, as well as Congress, was part of the problem.

The tenth anniversary of 9/11 brought a momentary upswell in bipartisanship as well as patriotism, but then it was back to the political wars. Many commentators have said that the recent great divide in American society is traceable to the contested 2000 presidential election between George W. Bush and Al Gore: Distrust ran so deep in the aftermath, there could be no rapprochement. In any event, Barack Obama finds himself, as he enters a year in which he seeks reelection, caught in a maelstrom— whatever its cause. Whether it engulfs him, even as it grays him, is to be determined.

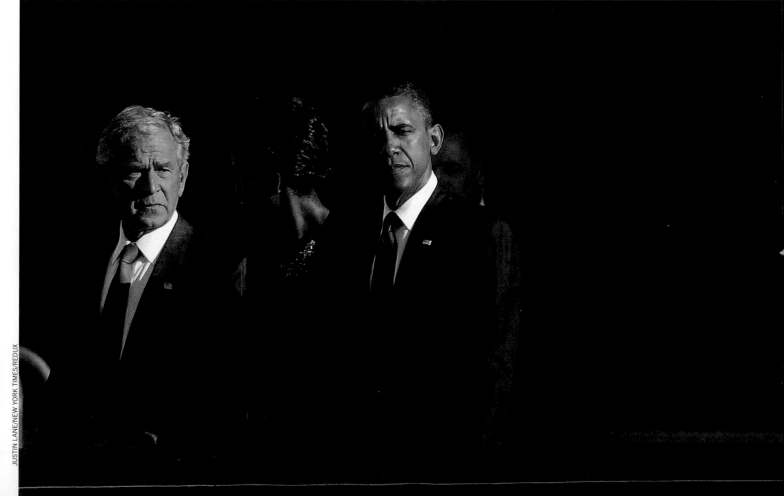

Fall

Please Don't! (Fall, that Is)

On September 27, an engineer tethered by ropes begins the process of conducting a stone-by-stone inspection of the exterior of the Washington Monument; the National Park Service has closed the landmark in the nation's capital indefinitely due to damage caused by a rare 5.8 magnitude earthquake that struck central Virginia on August 23. (Yes, in this Year of the Earthquake, even Virginia. And we are not yet done.) Throughout the autumn, work continues on the upper reaches of the monument to determine how best to effect repairs. Perhaps obviously, this photograph can also be seen as a visual metaphor of the fissures afflicting American society at this time, and also the search for possible fixes, as President Obama and a host of Republicans position themselves before the election year. In October, work on the monument is halted temporarily when wind gusts blow one of the roped-on workers off the monument and move him 30 feet to another side of the pinnacle. What that might mean is any philosopher's guess.

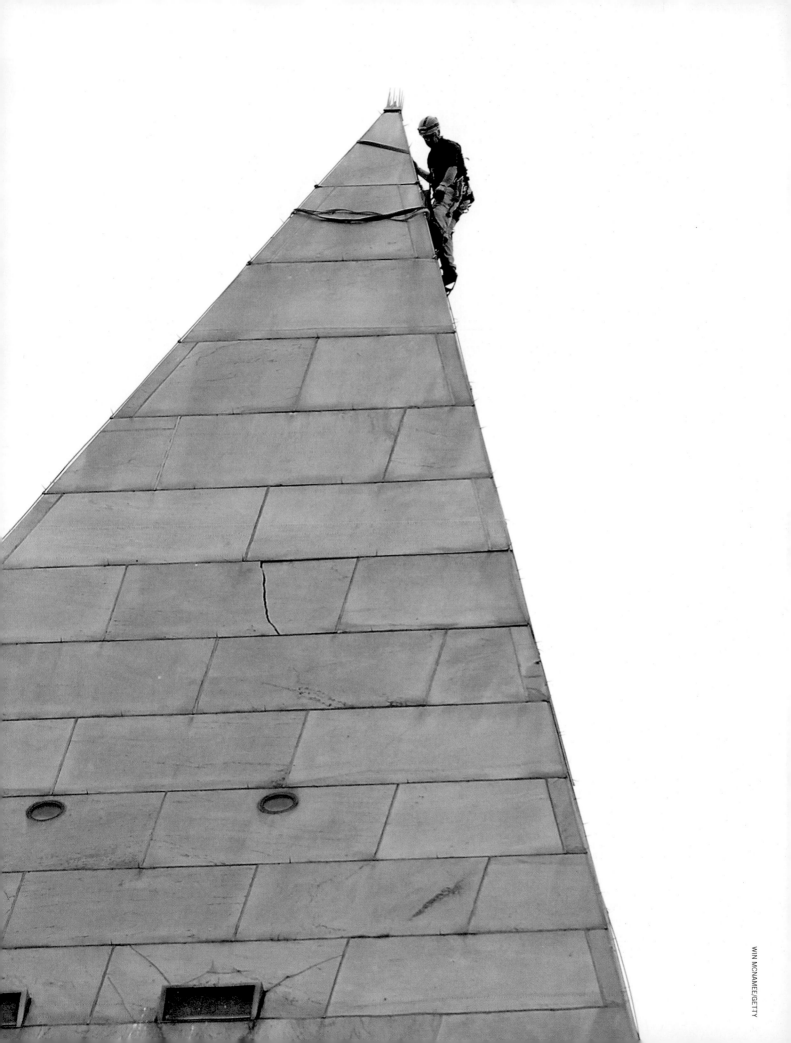

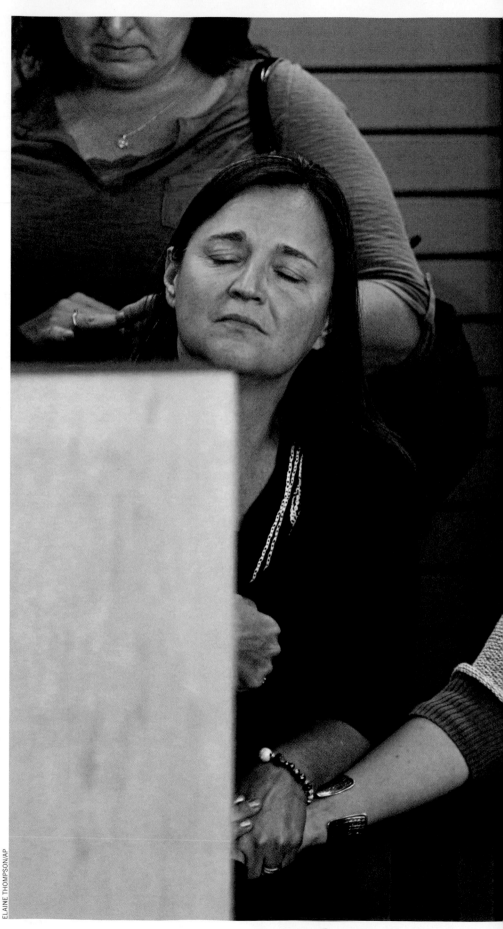

Liberty at Last

Amanda Knox is comforted by her sister Deanna, right, and holds the hand of her mother, Edda Mellas, on October 4 at Seattle-Tacoma International Airport, after returning home following four years of trial and imprisonment in Italy. The University of Washington student was studying in Perugia in 2007 and rooming with a young British woman, Meredith Kercher, when a night of horrible violence left Kercher dead by stabbing and Knox one of several suspects. Three people, including Knox and her Italian boyfriend of the time, were ultimately convicted in sensational trials that played out in the Italian tabloid press as much as they did in the courtroom. Although DNA evidence seemed to point to a conclusion that might have exonerated Knox, she went to jail. Her imprisonment, in particular among the three, became an international issue, bringing into stark relief the wide differences between Italian and American jurisprudence. An appeals court overturned her conviction on October 3 and she beat it out of Italy as fast as she could.

September 22 A month after **Hewlett-Packard blew it big time** with a hemming and hawing announcement about maybe spinning off its mainstay personal computer division, it names a new CEO: Meg Whitman, formerly chief of eBay and California's 2010 Republican gubernatorial candidate (she lost decisively to Jerry Brown). This caps a decade of boardroom battles for a company begun by two classmates in that storied Palo Alto garage. Interestingly, one of Steve Jobs's dying hopes in this season is that he has set Apple up in a way to avoid Hewlett-Packard's fate.

September 22 During the U.N. General Assembly in New York, Iranian president Mahmoud Ahmadinejad fiercely condemns the U.S. and European nations: "an assembly of people in contradiction with the inner human instincts and disposition who also have no faith in God and in the path of the divine prophets, replace their lust for power and materialistic ends with heavenly values." Delegates from the U.S., France, Germany, and U.K.—**confused, bored and above all disgusted**—walk out.

September 26 After bitter in-fighting, the U.S. Senate reaches a deal and the government **averts a shutdown** for the third time in 2011. The breakthrough comes when FEMA says that it has the funds to continue disaster relief payments through the end of the week, after which the new fiscal year will begin, resolving one of the main points of contention between Democrats and Republicans: Do we even have the money to help our fellow citizens (which we have always done in the past)? The following week an infusion of $2.65 billion goes to FEMA.

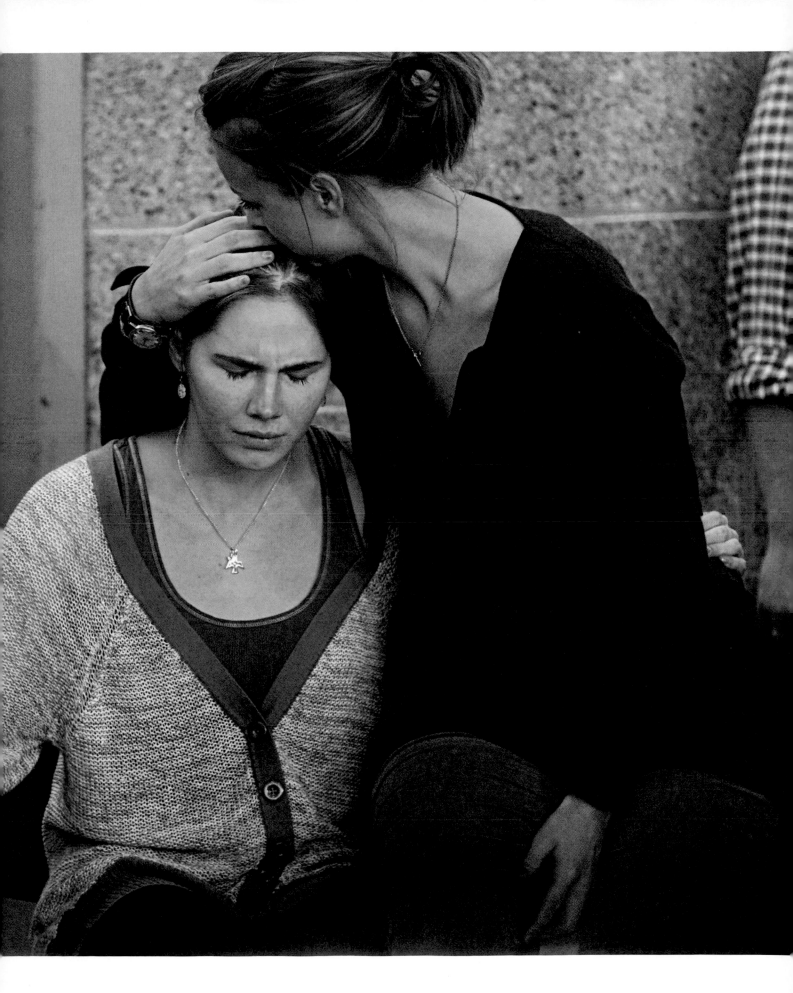

The Cute Ones

Some guys have all the luck, and Paul McCartney is one of them. First he gets to be a Beatle, which makes him one of the coolest and richest people on the planet, then he gets to marry the love of his life, Linda Eastman. Then he hits a bad patch when Linda passes away, and it seems he makes a mismatch in his second marriage, to Heather Mills. Okay. But *then* he bounces back not only with an artistic rekindling in his recent albums and in the score for a new work presented in late 2011 by the New York City Ballet (costumes designed by his daughter Stella), *but* he falls in love with a woman who is nearly as cool and rich—and cute—as he is, the American businesswoman and trucking-industry magnate Nancy Shevell. Sir Paul and his bride are seen here on their wedding day, October 9, at the Old Marylebone Town Hall in London after tying the knot before 30 friends in a low-key 45-minute civil ceremony, and prior to kicking off a party at Paul's London digs that will have the neighbors complaining about noise after midnight. Will Nancy, 51, still need him, will she still feed him, when he's 74 (only five years on)? It seems certain. He's a lucky guy.

September 27 Six Long Island high school students confess to **cheating on the SATs** by hiring a 19-year-old Emory University sophomore to take the tests for them. Samuel Eshaghoff allegedly racked up scores for the students ranging from 2,170 to 2,220 out of 2,400 and was paid up to $2,500 per test. Eshaghoff pleads not guilty. In October, the College Board, scrambling, hires a former FBI director to implement new security procedures before the next round of exams on November 5.

September 29 China's Tiangong-1 module is successfully launched into space from the Jiuquan Satellite Launch Centre in Gansu Province. The launch lays the groundwork for a future space station and underscores the country's **ambitions to become a space power**. "Tiangong" translates as "Heavenly Palace."

October 4 Italian Wikipedia shuts down in protest of a privacy law, dubbed **the "Wiretapping Act,"** which it says could lead to widespread Web censorship. The law requires Web sites to correct content that the parliament deems damaging to a person's image within 48 hours, with no right of appeal. Perhaps not by chance, two weeks earlier a wiretapped conversation that went wild on online media outlets linked Prime Minister Silvio Berlusconi to yet another alleged sex scandal. The timing of the law and the loss of Wikipedia enrages the citizenry, which takes to the streets in protest.

DANNY MARTINDALE/GETTY

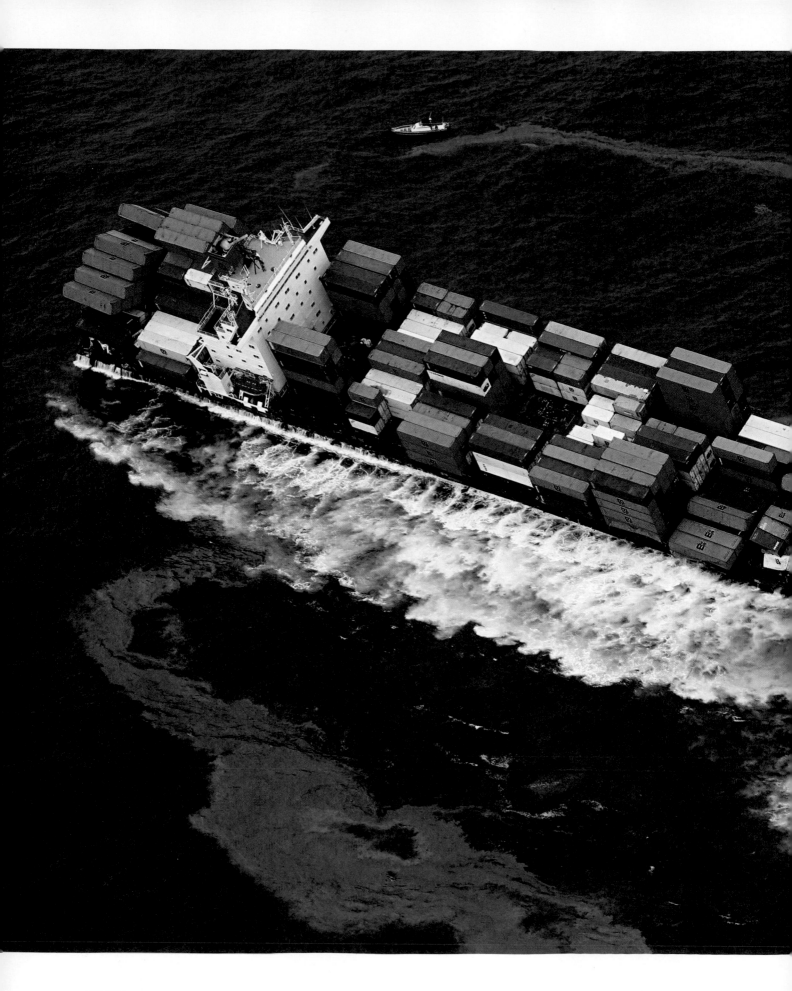

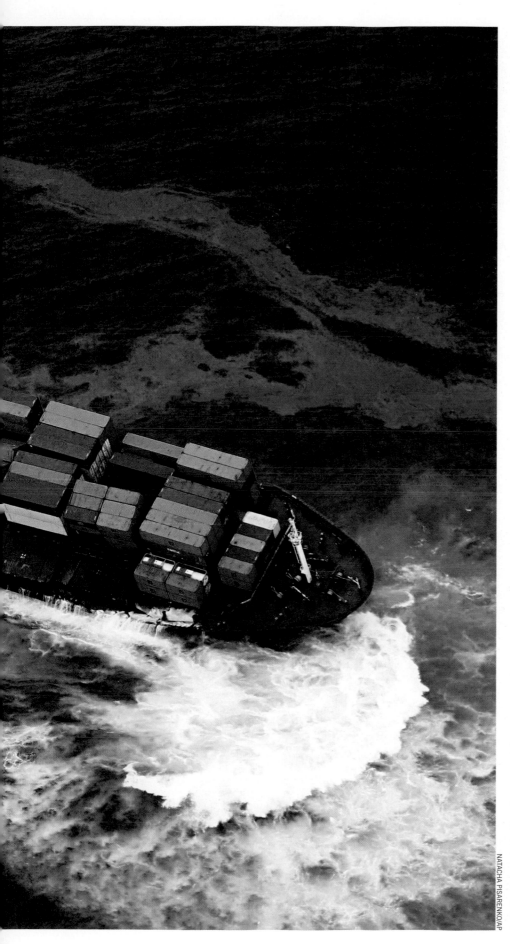

Listing, with Consequences

On October 13, the Liberian-licensed tanker *Rena* is 12 nautical miles from the east coast of New Zealand's North Island more than a week after it struck the Astrolabe Reef. The giant cargo ship became stuck fast, as hundreds of tons of heavy oil began to spill into the Pacific. When rough weather hit, containers were blown or knocked into the sea and the ship began to list, which assured that the vessel was going nowhere for a while. Fuel continued to pour out; over a thousand birds died; beaches were befouled; penguins had their feathers coated in oil. The slow response to the incident led to what has been called New Zealand's worst-ever environmental disaster—and this in the same year as the deadly Christchurch earthquake (please see page 8). The captain of the *Rena* is arrested and charged under New Zealand's Maritime Transport Act.

October 6 Talk about getting sacked! ESPN's *Monday Night Football* pulls Hank Williams Jr.'s iconic song "All My Rowdy Friends Are Coming Over Tonight" from its opening, where it had been a staple for 20 years. Why? Because **Hank had caught that weird Nazi bug** that earlier had afflicted John Galliano (page 15) and Lars von Trier (page 38). In Williams's case, he had made an ill-advised analogy during a *Fox and Friends* interview, saying that when President Obama and John Boehner teed up in June, it was like "Hitler playing golf with Netanyahu." He later said he was misunderstood.

October 7 Three women from Africa and the Arab world are awarded the Nobel Peace Prize for their nonviolent struggle to **promote peace and women's rights**: Ellen Johnson Sirleaf, the president of Liberia and first woman president in modern Africa; her countrywoman Leymah Gbowee, who is a peace activist; and Tawakkul Karman, a prodemocracy campaigner in Yemen. The committee has awarded Nobel prizes, in Peace and several other categories, only 40 times to women and 509 times to men since the program was started in 1901.

October 17 Richard Branson unveils the Virgin Galactic Gateway to Space, the **world's first commercial spaceport** in southern New Mexico. Adventurous (and wealthy) tourists will blast into space and experience six minutes of weightlessness for $200,000 a ticket starting in 2013. Branson christens the completed spaceport and mothership by rappelling down the side of the building while popping open a bottle of champagne.

October 18 Fifty-six **exotic animals are let loose** by a Zanesville, Ohio, man before he shoots himself. By late afternoon the next day, two wolves, a baboon, six black bears, two grizzly bears, 17 lions and lionesses, three mountain lions and 18 Bengal tigers are all "accounted for"—meaning they have been killed by authorities—and a lone monkey has likely become a meal for one of the big cats. One lucky grizzly bear, three leopards and two monkeys have been safely transported to the Columbus Zoo.

NATACHA PISARENKO/AP

Thailand Challenged

A Buddhist monk walks through floodwater outside the inundated 400-year-old Chai Wattanaram temple, a World Heritage site, in the city of Ayutthaya. The monsoon rains in Thailand were relentless this year, and flooding started in mid-July, then grew worse in the fall. As hundreds died, the crisis became so unabating that unique measures were put in place. The Thai cabinet announced on October 25 that it had looked at projected high tides through month's end, and declared five public holidays, Thursday through Monday, in 27 provinces that were already under water. Officials implored people to stay home, prepare food, or if possible evacuate and get to higher ground. On the same day, residents of Muang Ake village were told to flee after a dike failed and water rushed forth. The flooding affected more than 9 million, caused more than $5 billion in damages and saw more than 113,000 people take refuge in more than 1,700 shelters. As the waters crept higher, even some of the evacuation centers went under. Thousands were bused to a stadium in central Bangkok, since that city seemed to be relatively safe from the floods, but then the capital itself was breached, evacuations were made, and its airport was threatened. Some called it a 50-year flood, some called it a hundred-year flood. The terms and history didn't matter. The present reality did.

October 18 The presidential primary cycle heats up at the latest Republican debate in Las Vegas. Doing a 180 from his subdued presence in the previous week's New Hampshire set-to, **Rick Perry lambastes** Mitt Romney's "strong on immigration" stance, accusing Romney of employing two illegal immigrants to perform yard work. What ensues is near fisticuffs between the two men, with Romney placing a hand on Perry's shoulder in an effort to quiet his opponent. Which voice the American public most wants to hear is yet to be determined—and may not be either Perry's or Romney's. Tea Party–favored Herman Cain has just surged to the top of the polls.

October 20 Central Athens is filled with tear gas and firebombs as **Greeks protest** an extra round of austerity measures passed by parliament earlier in the day. The new measures, on top of tax hikes and pay cuts instituted in 2010, are meant to ensure additional creditor bailouts that will—it is hoped—keep the socialist country from bankruptcy. Today's demonstration leaves one man dead of heart failure, 74 injured and many more questions on how to solve the two-year-old Eurozone debt crisis.

SUKREE SUKPLANG/REUTERS

The Earth Shakes, Yet Again

Back on page 6, when we began our survey of 2011, we called this the Year of the Earthquake, and that was certainly apt—Christchurch, Japan (worst of all), even Virginia, and also the Bay Area in October, where a series of midsize temblors left the denizens of San Francisco and Oakland, who now take these shakes in stride, relatively unfazed. As we near the end of our survey, however, we visit another truly terrible quake—this one huge, 7.2 on the Richter scale, and in a vulnerable region—that rocked Turkey and killed hundreds. Two thousand two hundred and sixty buildings collapsed in and around the eastern Turkish city of Van, which is near the Iranian border, and more than 1,300 people were taken to the nearest functioning hospitals. Ercis is quite near Van, and on October 24, 13-year-old Yunus (left), a survivor, waits to be rescued from the rubble of an Internet cafe, the hand of one of the dead resting on his shoulder. Rescuers in Ercis have called for silence, in order to hear the cries of any still alive. Yunus is thus saved. So is 19-year-old Yalcin Akay, who was fortunately able to take a modern route by calling police on his cell phone. We are in a new age, but the eternal natural forces and human urges—earthquakes, floods, a fierce desire to survive, a fierce will to help—still apply.

October 21 President Obama announces that U.S. troops in Iraq "will definitely be **home for the holidays**," ending American participation in the eight-year war, in which more than a million U.S. troops have served.

October 21 Michele Bachmann's bid for the Republican presidential **candidacy is stung** by the group resignation of her top New Hampshire–primary staff. Confusion rules the day when Bachmann claims no knowledge of the four staff members' departure, one of whom immediately joins rival candidate Texas governor Rick Perry's campaign.

October 28 Winning **one of the greatest World Series ever played**—four games to three over the Texas Rangers—the St. Louis Cardinals come back from two runs down twice in Game Six to tie, then win in the eleventh inning, and prevail this night in Game Seven.

November 1 After a day in which half a million babies were born, the world wakes up to find there are now more than **7 billion people** on the planet—more than double the figure from 50 years ago.

FOCUS ON | Occupy Wall Street

I n LIFE's annual look back we attempt to put in perspective the events of the year, but if you are seeking a conclusive answer to the question, "What was/is Occupy Wall Street all about?" you will not find it in these four pages. We're not sure, yet. We can tell you what it wasn't. It was not just a convenient year-end bookend to the Tea Party movement, although it acts as such in our book and although it shares, at its molten core, the TP's populist spirit. It was not the exclusive property of Democrats or libertarians, although Jon Stewart, noting the franchising of Occupy Wall Street, said "They're like the Hard Rock Café of leftist movements!" Many of the Occupiers were leftist, sure, and some really weren't— they were blue-collar folks out of work, who wanted to once again be blue-collar *workers*. It was the '60s and organo and groovy and musical, yes, but it was also purposeful and not at all retro. It was, we think, a large and not often lucidly phrased complaint. And the complaint was one that many and diverse people would attach themselves to, firmly or loosely, and so Occupy Wall Street became far more creditable than any would have credited when it launched.

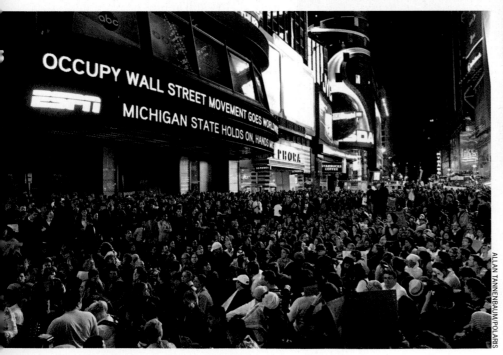

At left, the Occupy Wall Streeters take their protest uptown to the Great White Way, and fill Times Square on October 15. The reason for the relocation isn't precisely clear, and the demonstrators continue to shout slogans condemning banks, while not voicing any problems with Broadway or the Disneyfication of 42nd Street. Above: In a daily ritual of this particular autumn, commuters on their way to work pass still-sleeping protesters in Zuccotti Park. This image puts in stark relief two things: the engine driving the economy and the argument against that engine, but also the genius of our American democracy, where such a moment can be captured in such a peaceful photograph.

ALLAN TANNENBAUM/POLARIS

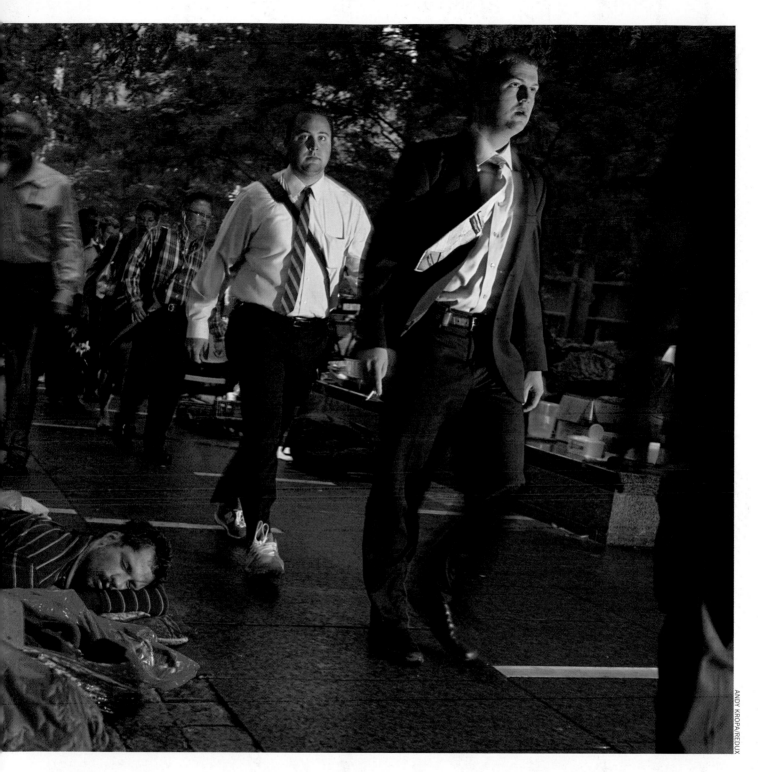

And when exactly was that? Well, as opposed to so much that is amorphous about Occupy Wall Street, this can be pinned down. A rally was called for September 17 at Zuccotti Park in Manhattan's downtown financial district with the urging: "Bring tent." Ever since, this small urban park has been the mecca of the movement. But Occupy Wall Street, which was instantly attractive as a very general concept— the relatively disenfranchised 99 percent versus the 1 percent that controlled 36 percent of all American wealth, in a time of economic distress when real unemployment in the

U.S. was in double digits—quickly spread outward. In New York City on September 30, 2,000 marchers surrounded police headquarters (adding police brutality to a growing menu of grievances), and five days later 15,000 clogged Lower Manhattan. On the 15th, the protest moved north, with 6,000 filling Times Square, focusing its chants on the military recruitment center. (At this point, and later in October when the protest visited the BlueCross BlueShield headquarters, many asked: What's the message, again?)

In those same weeks the crusade went nationwide and

overseas, and by late fall more than 70 cities and 600 communities in the U.S., as well as 900 cities worldwide, had seen protests that were philosophically tied to Occupy Wall Street. In different places, different scenes: European rallies were more prone to violence than were American ones, although hundreds would be arrested during the season in New York, tear gas would be deployed in Oakland, pepper spray in Denver, and heightened tensions would lead to confrontation and handcuffs in Chicago, Nashville and Atlanta.

As October turned to November, polls showed that two thirds of Americans supported the protesters' argument that wealth was inequitably distributed, two thirds didn't see the need to raise corporate taxes, and two thirds approved of increased taxes on millionaires. How to reconcile all that? The politicians sure didn't know. President Obama seemed to be sidling up to the Occupy Wall Street movement at first, but when the chanting turned to hanging his Federal Reserve chairman Ben Bernanke, he commented less.

Now comes the winter of this massive discontent. Beginning before Thanksgiving, protesters in the Northeast and elsewhere started to bring in better tents. (If this were not an anticapitalist movement, Occupy Wall Street could do with sponsorship by North Face or Patagonia.) Sweaters were replaced by down-filled parkas, some cops grew weary and started to lash out, some complainants answered inertia with spontaneous acts of incivility that they knew would end in confrontation or arrest.

At year's end, Occupy Wall Street found itself conjoined forevermore with the Tea Party movement in the history books. Two thousand and eleven was when economic and governmental forces at play since the 1970s—forces that resulted in changes in regulation and a vigorously accelerating disparity in wealth and opportunity—led to a response. Not a response at the polling stations (yet), but in the streets and the public square.

FRANK POLICH/REUTERS

YURI GRIPAS/REUTERS

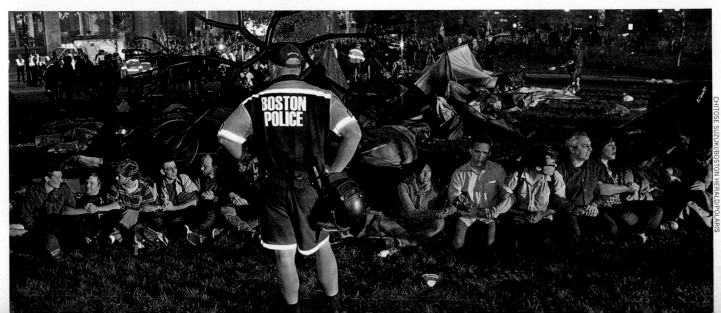

CHITOSE SUZUKI/BOSTON HERALD/POLARIS

The movement has legs. Opposite, in America, clockwise from top left: Kayakers dressed as Robin Hood, part of the Stand Up! Chicago coalition, paddle down the Chicago River on October 10; protesters sign an oversize copy of the U.S. Constitution during the Occupy DC event in the nation's capital on the same day; and a Boston cop chills with protesters on the Greenway on October 11, perhaps parsing the recent Red Sox choke. There will, subsequently, be arrests in Boston, violence and arrests in Chicago, and confusion in Washington, where scores of men and women who are up for reelection in 2012 don't know how to respond to Occupy Wall Street. At right, on October 15, a protester in Rome hurls a canister while his colleagues smash shop windows and torch cars. There is no question that the Occupy Wall Street franchises in Europe and Asia are descendent from the antiausterity, antidisparity protests that have been rocking London (page 68) and other cities for many months. Below: Back in New York, the protests grow to be many and varied. At one point in chilly late October, parents bring their young kids for a sleepover demonstration, which of course draws criticism: What in the world are you doing? But this child—photographed in Zuccotti Park on September 30, quite near the beginning of the Occupy Wall Street movement—and her sign provoke interesting questions. Indeed, what is the future? What can we do for her and her generation? What are we trying to do? Is this, in 2011, a crossroads? Only the future—her future—will say.

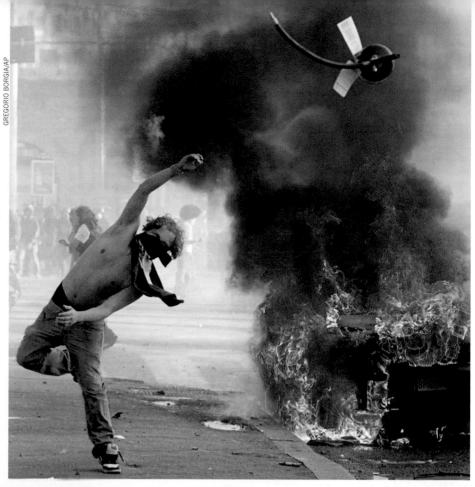

Lady Gaga

To a greater or lesser extent, all celebrities are playing roles on a daily basis. Some are more authentic, more in their own skin, than others. You really do get the impression that George Clooney's a pretty nice guy who doesn't care if he says something a little provocative as long as it's delivered with that sly charm (he doesn't use Twitter, he claims, because he drinks at night and doesn't want to screw up his career after a few cocktails). Nonetheless, Clooney is a celebrity by trade, and when he awakens each morning he is asked to play George Clooney, and does his best to convey the chosen image, in his case one dripping in insouciance and savoir faire, flavored by a bit of bad boy. Errol Flynn played a public role, as did Liz Taylor. John Lennon was responsible for his own image, and so was Johnny Rotten.

Every now and again we are presented with a *persona*. Marilyn Monroe was one: Norma Jeane Baker Mortenson admitted that she turned "her" off and on as bemused her, or profited her. At another extreme, Pee-Wee Herman was one; Paul Reubens was and is anonymous in public (well, not quite anonymous enough, as it turned out), but Pee-Wee was and

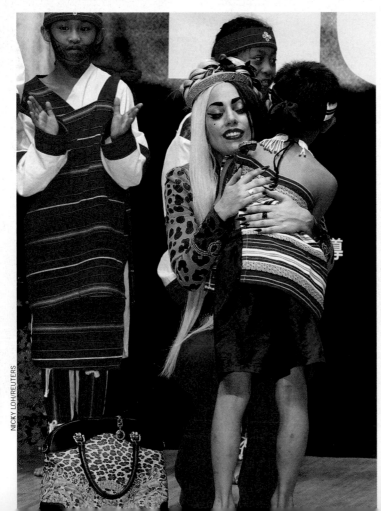

NICKY LOH/REUTERS

CHRIS PIZZELLO/AP

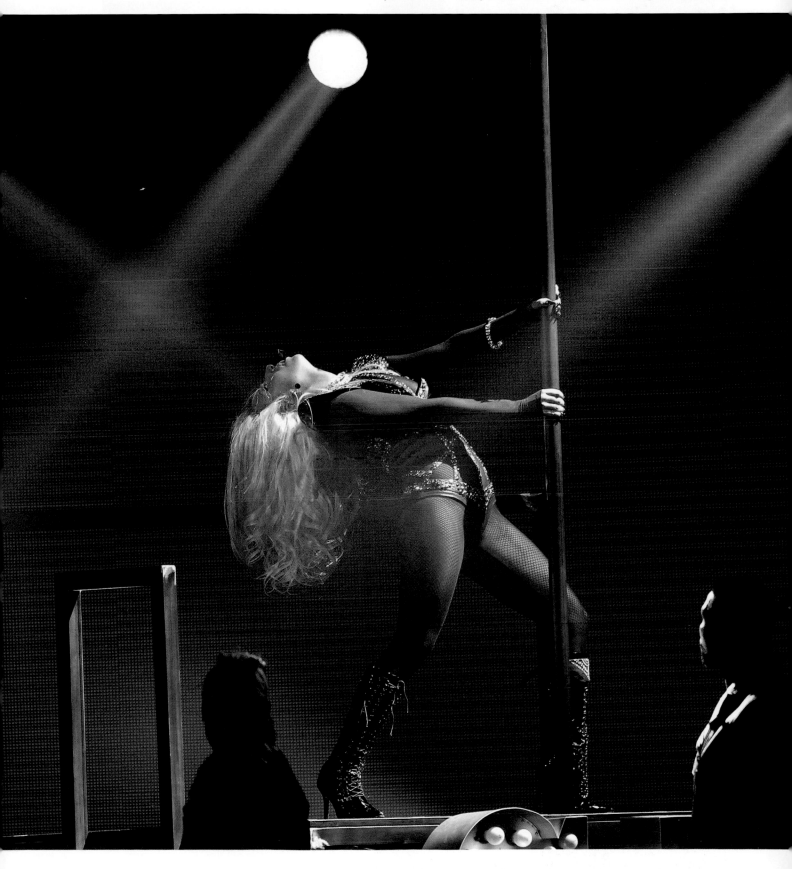

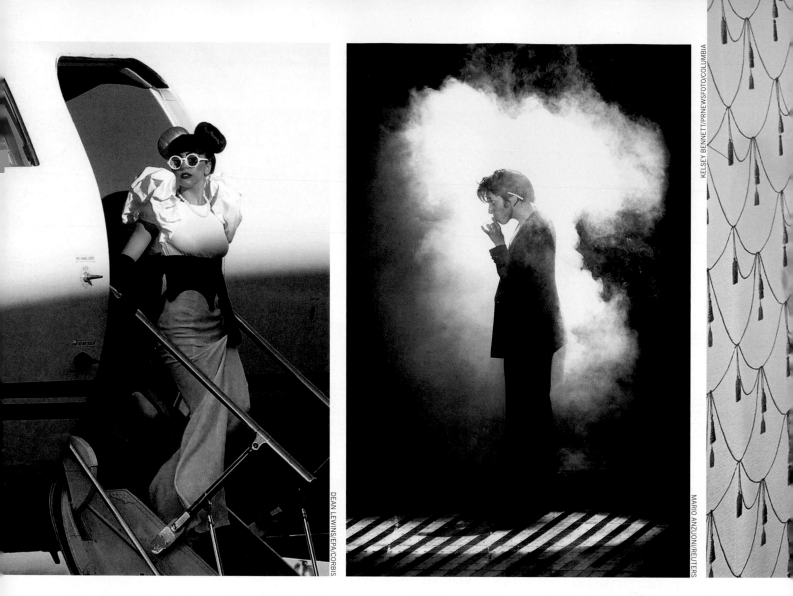

remains famous. Soupy Sales was a persona. At the Grand Ole Opry, Minnie Pearl was a persona.

Madonna continually morphs before our eyes into different and often dangerous feminine creatures, but in her case that is, at least, her real name.

Not that it really matters to this singer/dancer/persona's fame and fortune, but who was—and who is—Lady Gaga?

Well, she is, like Madonna, a female singer-songwriter of Italian American heritage. Twenty-five-year-old Stefani Joanne Angelina Germanotta is a New York University dropout who started her career on Manhattan's Lower East Side; she was discovered by the rhythm and blues singer known as Akon. Perhaps crucially, Germanotta developed the Gaga thing before her first album, *The Fame*, was released in 2008. It was such a huge success, with hits like "Just Dance" and "Poker Face," that it may well have been too late to invent Gaga if Gaga had not already existed.

Once Gaga did exist, Germanotta had choices: ride it for a while, ride it forever, or forsake it. So far, she's riding. But also, her music has been so good and her talents are so substantial that she has, in 2011, begun to transcend her persona. As we mentioned on page 12, she arrived at the Grammy Awards

inside an egg. That's the schtick. And so was her promise of "a Marilyn Monroe moment" just before serenading former President Bill Clinton at his foundation's charity concert in late October, where she co-headlined with Kenny Chesney, Usher, Bono and the Edge. But the woman can really sing and dance, and in her writing she is in tune with the young. What that might mean in the next 10 or 20 years will be interesting to watch—interesting, at the very least.

Tony Bennett, who didn't slow down a bit at age 85 this year, released a second album of duets in 2011, and among those he invited to share the microphone were Amy Winehouse (please see page 108) and Lady Gaga. Sure, Tony kept himself and his career in-the-moment with these choices. But he doesn't make such important decisions casually; he has a legacy at stake. As the CD hit in the fall, he found himself talking to the press about both women. He was poignant in his comments about Winehouse, whom he genuinely liked and whose battles he empathized with. As for Gaga, who sang "The Lady Is a Tramp" with him, he praised her professionalism as well as her talent. He predicted she will be around for a long, long time.

And the only remaining questions are: As what? As who?

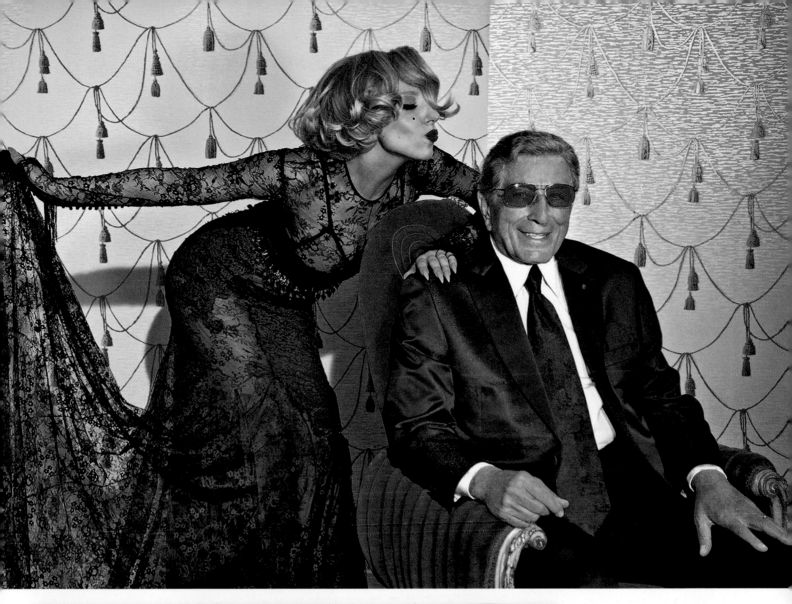

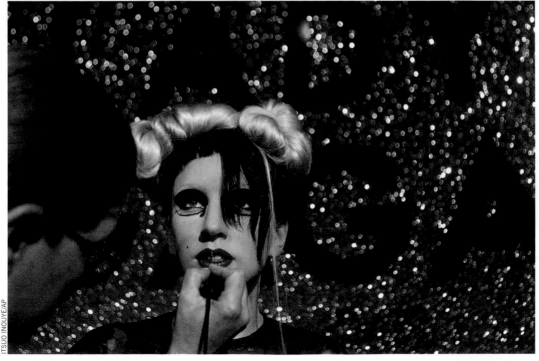

Opposite, left, on July 9, the Lady deplanes in Sydney, Australia, where she will perform a concert at the Town Hall theater. In the past few years, she has rarely walked through a door and into the world as Stefani Germanotta; for now, at least, she wants all photos to be of Gaga—or of Gaga being someone else. The photo at right is from the MTV Awards in late August when she notoriously appears as a male singer. "My name is Jo Calderone," she announces. "Lady Gaga? She left me! She's [expletive] crazy. For example, she gets out of bed, puts on the heels. She comes out of the bathroom dripping wet and she's still got the heels on. And what's with the hair? At first it was sexy, but now I'm just confused." Confusion is Gaga's stock-in-trade. Above: On the day she records with Tony Bennett, in a photograph made by his granddaughter. Left: The ultimate confirmation of fame, a statue at Madame Tussauds. This waxwork, one of more than half a dozen worldwide, is being retouched on September 28 by production maintenance manager Petra van der Meer for an exhibition in Tokyo.

LIFE
Remembers

In each year, rain does fall—and for us, it falls in the form of friends who left us. On the next many pages we fondly recall those who passed away in 2011, many of them familiar subjects to readers of LIFE. First of all, of course, our darling Elizabeth.

Elizabeth Taylor

Here she is in 1956 on the set of *Raintree County,* one of her earlier "adult" films. By now the 25-year-old young woman already has a full and fruitful career as a child star behind her, has been declared by many (by acclaim!) the most beautiful creature on the planet and is starting to exhibit for her fans the unforeseen depths of her talent (her role in *Raintree* leads to the first of five Academy Award nominations; she will win twice for Best Actress). Ahead of her are Mike Todd, Eddie Fisher, Richard Burton, an unworldly celebrity, a legendary philanthropy, Michael Jackson, Larry King, a ton of jewelry, many bouts of illness—and a final transcendence into American iconography. Farewell to the last Movie Star.

Steve Jobs

On August 6, 1997, Apple Computer honcho Jobs, one of the more self-confident corporate executives in America, is nervous, and paces back-stage, checking the latest news on his devices, before appearing at Macworld Expo 5 to announce a startling alliance between his company and Microsoft. Very rarely have innovational genius, entrepreneurial genius and managerial genius come together in one individual as they did with Jobs; some might nominate Ford or Edison, and then let the debate begin. If Hewlett and Packard's was the Adam and Eve garage story in Silicon Valley lore, then that of the two Steves—Jobs and Wozniak—was just as compelling (and even more unlikely). Jobs, a college dropout, built his dream company, lost it, came back to build it stronger: an American story of grit and redemption. He died far too young, at age 56, of pancreatic cancer, and the world was left to wonder: What else might he have given us?

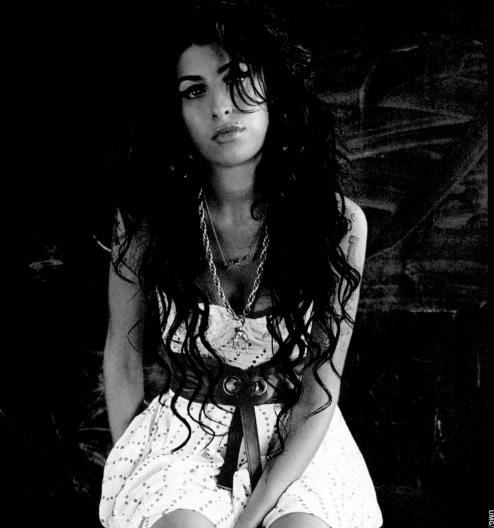

Amy Winehouse

Sometimes we react with a gasp, sometimes with a sigh. When the world learned that the British neo-soul singer Amy Winehouse had died, there was the latter reaction: such a shame, so much talent, so many demons. We display here a photograph from the shoot she did for her second album, *Back to Black,* upon which her reputation rests. In the lyrics to the several self-penned hits—"Rehab," "You Know I'm No Good," "Back to Black," "Tears Dry on Their Own"—Winehouse was desperately self-reflective but also defiant. It is to be supposed that *Back to Black* would have been her seminal recording had she lived to be 80. As it was, she died at home at age 27 in late July.

Clarence Clemons

The Big Man always had a Boss, as did everyone in the E Street Band, right from the earliest days on the Jersey Shore to the most recent tours on the world's grandest stages. The Boss was in charge. But the Big Man was singular too. Clarence and Bruce (Springsteen, that is, seen here with the guitar) were, in a phrase that would not be out of place on any E Street album, blood brothers. Particularly in the early records through to *Born to Run* and *Darkness on the Edge of Town* (this photo is from the 1978 Darkness tour), Clemons's sax was a signature of the Springsteen sound. On stage, the Big Man was indispensable, which is certainly why the future of the band was reassessed by the Boss in the wake of Clemons's death.

Betty Ford

On January 19, 1977, the First Lady seems pretty happy to be the outgoing First Lady as she dances on the table in the Cabinet Room in the West Wing during her husband Gerald Ford's last full day in the White House. The President has been beaten, two months prior, by Jimmy Carter, and the Fords are about to be evicted. Betty's best days are ahead of her: In 1982 she will, having fought her own battle with the bottle and with drugs, cofound the Betty Ford Center in California, dedicated to helping people overcome chemical addictions.

Geraldine Ferraro

Her lasting legacy will likely be a historical footnote: the first female (and the first Italian American) candidate for Vice President of the United States for either of the two major parties (she ran alongside Walter Mondale, who lost to Ronald Reagan in a landslide in 1984). But native New Yorker Gerry Ferraro should never be relegated to a postscript. A lawyer by trade, she joined the Queens County D.A.'s office in 1974, later heading the new Special Victims Bureau that dealt with sex crimes, child abuse and domestic violence, then won election to the House in 1978. She fought for women's rights, kids' rights, minority rights—everyone's rights.

Sargent Shriver

In May 1966, Robert Sargent Shriver Jr.—in his role as Director of Economic Opportunity, but also because of who he is—walks and talks with residents in Pittsburgh. He has already been, at this early point in what will be a long life (he was 95 when he died in January), a driving force in the founding of the Peace Corps, and he is yet to be a (failed) presidential candidate. Shriver will help his wife, Eunice Kennedy Shriver, invent the Special Olympics, getting things going initially on the grounds of their Maryland estate; and he will advise, wisely, all the various Kennedys. He was a man who was born to serve.

Nick Ashford

In the 2005 photograph below, Ashford sings as his wife and eternal collaborator, Valerie Simpson, plays one of the biggest hits they ever wrote, "Ain't No Mountain High Enough." Ashford and Simpson, who met at a Baptist church in Harlem in 1963 and married in 1974, are destined to be remembered first as songwriters—Motown staples "You're All I Need to Get By" and "Ain't Nothing Like the Real Thing," Chaka Khan's "I'm Every Woman," Teddy Pendergrass's "Is It Still Good to You"—but they were wonderful performers as well, and had their own chart-climbers in the 1980s. When the music world lost both Nick Ashford and Jerry Leiber, another storied half of a songwriting collaboration, on the same day, August 22, the airwaves were filled with reminiscences of both men, and with their absolutely terrific songs.

George Shearing

In 2007, despite the fact that most of his sensational career as a jazz pianist had been spent in the U.S., Shearing was knighted in London. He later expressed his life story with bemusement: "So, the poor, blind kid from Battersea became Sir George Shearing. Now that's a fairy tale come true."

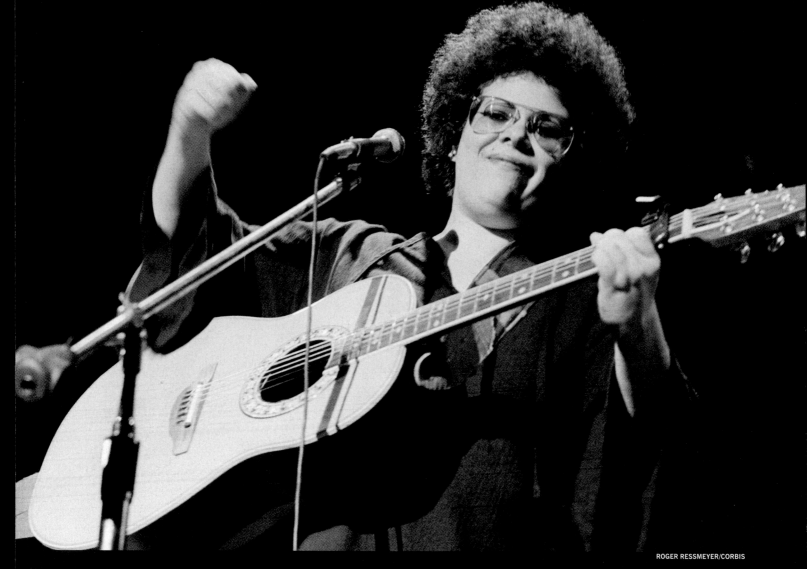

ROGER RESSMEYER/CORBIS

Phoebe Snow

There was so much more to this singer-songwriter than her enormous hit "Poetry Man." It was apparent to all in music that Snow was preternaturally gifted, but in 1975 she gave birth to a severely mentally impaired baby, Valerie Rose. Snow refused to institutionalize her, and for a while tried to balance a professional career with that of a single mother, then finally dedicated herself fully to her daughter's care. Valerie died in 2007, and Snow was reemerging on the music scene when she herself fell victim to health problems that had plagued her for years, ultimately suffering a stroke and a brain hemorrhage. She was 60 years old when she died.

Jerry Leiber

Jerry relaxes as his partner, Mike Stoller, tickles the ivories. Their hits included "Hound Dog," "Kansas City," "Jailhouse Rock," "Young Blood," "Yakety Yak" and a host of others. They didn't sing, but you couldn't turn on the radio without hearing Leiber and Stoller.

MICHAEL OCHS/GETTY

Jane Russell

This altogether stunning portrait of actress Jane Russell was made for LIFE in 1942, just before she was about to be, *ummm,* noticed. The aspirant singer had already filmed the Howard Hughes–auteured Billy the Kid flick *The Outlaw,* which would secure her fame, but the movie wouldn't be released until 1943, and then only in a limited way while censorship battles, focused on Russell's astonishing cleavage, were waged, won and then overturned. The movie would not go wide until 1946, by which point Russell was, along with Betty Grable and Rita Hayworth, a veteran World War II pinup girl and, in her mid-20s, already a Hollywood legend. Russell made her mark in barely more than 20 films and switched back and forth between singing and acting; she amiably went along with gags about her voluptuous figure in light comedies costarring such friends as Marilyn Monroe and Bob Hope, the latter of whom once memorably cracked, "Culture is the ability to describe Jane Russell without moving your hands." Off screen, she adopted three children and chanced upon her cause, founding, in 1955, the World Adoption International Fund.

ELIOT ELISOFON

Jackie Cooper

The child star was a direct contemporary of Jane Russell, born a year after her in 1922, so if he wasn't yet ogling her in this publicity still made circa 1930, he would be soon enough on Hollywood's back lots. At age nine, Jackie became the youngest ever to be nominated for Best Actor in a Leading Role, for his performance in *Skippy,* but it must be said the film's director, Norman Taurog, deserves credit too: Taurog, who in fact was Cooper's uncle, at one point coaxed tears from the boy by pretending to shoot his dog off-set. Jackie's fame grew with the success of the *Our Gang* shorts of the early 1930s. Cooper, like Elizabeth Taylor, made the dicey transition from child star to successful adult actor, though his later work, largely in television, wasn't on a scale approaching hers. He was also a TV exec, and is credited with casting Sally Field as Gidget. Later, he played the newspaper editor Perry White in the Christopher Reeve *Superman* films. For much of the 20th century, Jackie Cooper was on the screen.

Susannah York

Seen here in the 1963 film *Tom Jones,* in which she played opposite the boisterous Albert Finney, the lovely York was at the forefront of a youthful British cultural invasion that extended well beyond the Beatles and the Dave Clark Five. For this reason, many Americans, if they remember her at all, remember her as a figure stuck in time—and yet she had a good, long career. When she was most famous, she was a child of the '60s, a kind of English Jane Fonda. As the decade began, she was doing period romances like *Jones,* based on the Henry Fielding classic, and just a few years on she was being nominated for a Best Supporting Actress Oscar for her role in the edgy 1969 film *They Shoot Horses, Don't They?* Meantime Fonda was transitioning from *Barefoot in the Park* to the sexploitation epic *Barbarella* to starring roles in films like *Horses* and *Klute.* The times they were a changin', and so were such as York and Fonda. Like Fonda, York soldiered on—making many more movies (a lot of them in England, but also she played the role of Superman's mother in the 1978 Hollywood megahit as well as in its sequels *Superman II* and *IV*) and taking star turns on the stage, including in her hit one-woman show, *The Loves of Shakespeare's Women,* which began in 2001 and toured internationally almost since—until her death.

CONDÉ NAST ARCHIVE/CORBIS

Sidney Lumet

Usually in the LIFE Remembers section of our *Year in Pictures,* the photographs we are forced to choose of famous, bygone movie directors are moody, serious portraits showing the great man or woman looking through the lens. Well how about this!? Sidney Lumet, born in 1924, was an actor long before he moved behind the camera, having debuted in Yiddish theater productions in his native Pennsylvania at the age of four. In this picture, made circa 1940, he is playing Jesus in the play *Journey to Jerusalem.* It wouldn't be until 1957 that he made his directorial bow, but once he got going, he really got going, producing, writing or directing 40 films in the next 50 years. He was nominated for the Best Director Academy Award four times (for *12 Angry Men, Dog Day Afternoon, Network* and *The Verdict*). Roger Ebert called him "one of the finest craftsmen and warmest humanitarians among all film directors."

James Arness

He was the John Wayne of the small screen, but more importantly: He was John Wayne in real life, the authentic deal in a way even Wayne never was. A native Minnesotan, the strapping six-foot-seven Arness stormed ashore on Italy's Anzio beachhead on January 22, 1944, as a rifleman with the U.S. 3rd Infantry Division; his honors from World War II would include the Bronze Star, the Purple Heart, the World War II Victory Medal, the Combat Infantryman Badge and the European-African-Middle Eastern Campaign Medal with three bronze battle stars. After that, TV seemed easy, and he sauntered through 20 years as a fictive American hero: Matt Dillon, the sage Western marshall at the center of the phenomenally popular *Gunsmoke* series.

Leslie Nielsen

Tinseltown is the smelter in which the geniuses of the film world invent. It is also, for some, a place of reinvention. The Canadian actor Leslie Nielsen was cast in a multitude of small movies and larger TV shows in the 1950s and '60s—did you know he played the Revolutionary War hero Francis Marion in the Disney series *The Swamp Fox*?—but was always asked to render a pretty serious guy. In fact, Nielsen was not. It is the audience's great good luck that this was finally realized. In 1980 his inner wackiness found its way to celluloid in *Airplane!* and graced (if that's the right word) the *Naked Gun* movies in years to follow; this photograph is from *The Naked Gun 2½: The Smell of Fear.* Sometimes, Hollywood is blind to the talent in its midst. Sometimes, it gets lucky.

EVE GOLDSCHMIDT/UNIVERSAL/DPA/CORBIS

PARAMOUNT/EVERETT

Peter Falk

Television audiences, when allowed to visit with a favorite character on a weekly basis, tend to fall in love. For years and years, Americans simply could not wait for James Arness's Marshall Matt Dillon to revisit on Monday night. Similarly, later, they made sure to have dinner finished and the cocoa poured before settling down with Angela Lansbury in *Murder, She Wrote* or Peter Falk in *Columbo*. Falk in particular made it easy to sympathize with, empathize with and/or truly love his character, a trench coat–wearing everyman gumshoe who dissembles continuously, has a lovely relationship with an offstage wife and is the smartest guy in the room. Falk was, too. He could play comedy broad or sly, and he was immensely affecting in Hollywood productions and in smaller, cinema verité films featuring, or directed by, his buddy John Cassavetes. Falk was Columbo: never what he seemed, eclectic, nonpareil.

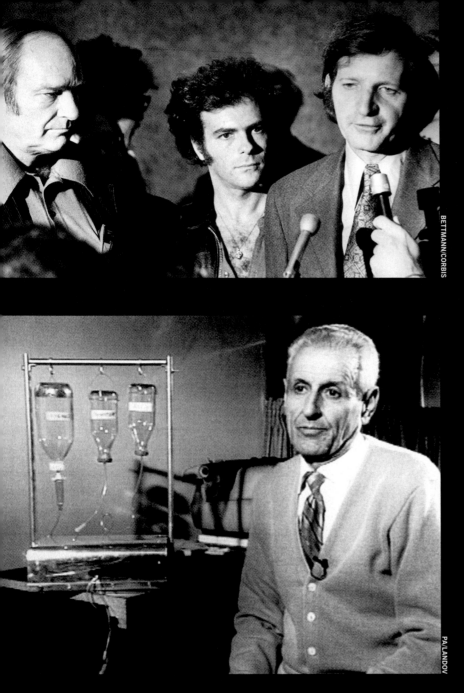

BETTMANN/CORBIS

PA/LANDOV

Leonard Weinglass

When acting on principles that society deem rightish or leftish—and whether or not that is the correct thing to do—lawyers who behave with conviction are an interesting breed. Leonard Weinglass was one such attorney. He is seen here, in Chicago's Federal Building, along with two clients who helped make him famous, David Dellinger (left) and Jerry Rubin (center). They were two sevenths of the Chicago Seven, who were convicted in a wild and wooly trial of conspiracy, inciting to riot and other charges stemming from protests they'd organized during the 1968 Democratic National Convention (convictions later overturned). Weinglass was a patriot—he was for a few years chief advocate for the United States Air Force—but some would never see him this way, as he also represented Daniel Ellsberg, Angela Davis, Kathy Boudin, John Sinclair and the Cuban Five. America remains an interesting country.

Suze Rotolo

She is remembered because she was in a photograph (not the one opposite, but another frame from the same take that has since been lost) that became the cover art for the 1963 album *The Freewheelin' Bob Dylan*. She was Dylan's principal girlfriend in the early '60s, and for many people the picture captured the happy, bohemian life of Greenwich Village better than any other. In this period, Rotolo, not long out of high school, was working for the Congress of Racial Equality as well as the antinuclear group SANE, and her political views influenced the folksinger greatly. Long after she and Dylan had split, which happened in 1964, Rotolo continued with a fruitful life in her native New York City, writing, teaching at the Parsons School of Design, before succumbing to lung cancer this year. She lived a life completely independent of Bob Dylan, but will always be remembered for a single photograph, a singular time and several songs—"Don't Think Twice, It's Alright," "Tomorrow Is a Long Time," "One Too Many Mornings," "Boots of Spanish Leather"—that Dylan wrote when thinking of her.

Dr. Jack Kevorkian

The man nicknamed Dr. Death did not kill himself, though many of his opponents might wish that he had years earlier. The pathologist from Michigan was certainly the country's and probably the world's most vocal and active champion of a terminally ill patient's right to die: "Dying is not a crime." Of course, some religious precepts do consider euthanasia a crime against God, and various state and federal laws have such precepts at their core. Kevorkian went to jail in 1999 for second-degree murder and remained there for eight years, finally being released only on the condition that he would no longer participate in another's suicide. By his own reckoning, he had already assisted some 130 people in ending their lives.

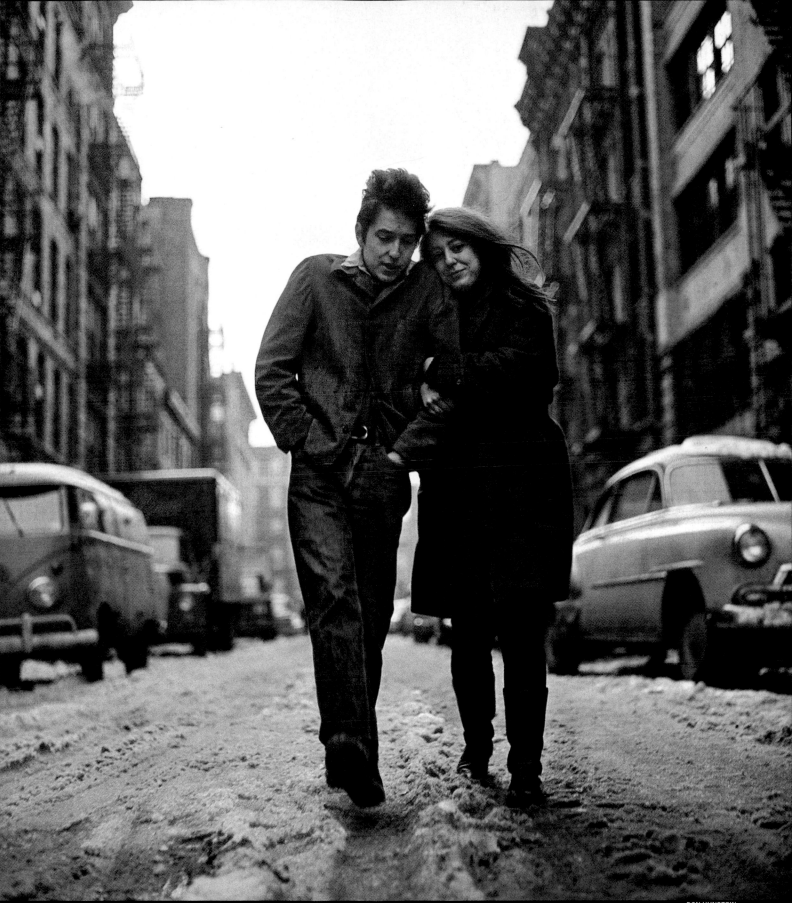

Jack LaLanne

Before there was Jane Fonda, before there was Richard Simmons, there was Francois Henri LaLanne. His pioneering show on public broadcasting was the *French Chef* of exercise, and he was to jumping jacks what Julia Child was to coquilles St. Jacques. A former junk food addict turned healthy-living evangelist (his twin rules of nutrition were "If man made it, don't eat it," and "If it tastes good, spit it out"), LaLanne won a Mr. America title and, with his energy, enthusiasm and natural charisma, parlayed that burst of celebrity into a career as America's Preeminent Fitness Superhero. He started a chain of health clubs, and to promote his growing enterprise he proceeded upon a succession of stunts—hard-to-do stunts, but stunts nonetheless. In this photograph, LaLanne, at age 41, celebrates his swim from Alcatraz Island (in the distance) to Fisherman's Wharf in San Francisco, a passage he accomplished while wearing handcuffs.

Joe Frazier

When he was a boy, his father brought home to the family farm in South Carolina a black-and-white television set. Folks from around would gather at the Fraziers' to watch the fights, which featured such champions as Sugar Ray Robinson and the Rockies Marciano or Graziano. Young Joe wanted a part of that. He fashioned a heavy bag out of a burlap sack stuffed with rags wrapped around a brick, and would lay into it. What a brawler he became, moving ferociously through the amateur ranks and winning the 1964 Olympic gold medal. His career—truly, much of his life—would be defined by three tremendous bouts against Muhammad Ali, who as Cassius Clay had himself won Olympic gold in 1960. If Frazier at first had no problems with Ali as a man, Ali's relentless taunting of Frazier (he called him a gorilla, and worse) eventually got to Frazier, and by the time they met in the so-called Fight of the Century in 1971 there was bad blood. That was a great fight, and Frazier became the first boxer to beat Ali. Ali got his revenge in the rematch, and then came the Thrilla in Manila. The savagery of that fight will be remembered forever by boxing fans. It wasn't clear that either man would be able to answer the bell for the 15th round, but it was Frazier's corner that first threw in the towel. The fight took its toll on both boxers, and Frazier entered the ring only twice more. In recent years the rivals reconciled, Frazier saying he forgave Ali for the things he had said, Ali saying he had the utmost respect for Frazier. He and the entire boxing world mourned Smokin' Joe when he died of liver cancer in November, only 67 years old.

Grete Waitz

Felled by cancer at age 57, the Norwegian runner, seen here with the laurels of her 1983 win in the marathon at the World Outdoor Track and Field Championships in Helsinki, was never slowed in her lifetime by the expectations of others. She was obviously fast as a girl, but her parents found it hard to credit that she might find a life as a champion runner. Still a teen, she won national titles on the track at 400 and 800 meters, and made it onto the Norwegian Olympic team in 1972. In 1975 she was moving up in distance and broke the 3,000-meter world record. In 1978 she was invited to run in the New York City Marathon, and that year she won the first of her nine Big Apple titles. Grete Waitz was a woman of grace and graciousness—and great speed.

STEVEN E. SUTTON/DUOMO/CORBIS

Duke Snider

For a brief time in the 1950s, New York City's major league ballparks hosted, on a daily basis, the three finest center fielders in the land: Willie, Mickey and the Duke. Willie was Mays of the Giants, Mickey was Mantle of the Yankees, and Duke was Edwin Donald Snider of the Brooklyn Dodgers, a.k.a. the Duke of Flatbush. The left-handed batter hit 40 or more homers in five straight seasons from 1953 through '57, and, along with teammates including Jackie Robinson and Roy Campanella, helped the Bums vanquish the hated Yankees in the 1955 World Series. As if a human symbol of the transaction, Snider was never quite as good after the Dodgers relocated from New York to Los Angeles in 1958.

NICK LAHAM/GETTY

Dan Wheldon

It is paradoxical that race car drivers, whom the fans never really see in competition—we see the car—often seem the most human of athletes, with distinct, knowable personalities. Junior Johnson. Richard Petty. Mario Andretti. Jackie Stewart. Dale Earnhardt. The British open-wheel racer Dan Wheldon, only 33 when he died in a 15-car wreck during the IndyCar World Championships at Las Vegas Motor Speedway on October 16, was in the tradition. He was self-effacing and affable, with a quick smile and a keen sense of humor. His fellow racers liked him as much as those in the stands did. In his too-brief career he had already won the storied Indianapolis 500 twice, including this year's running. Car racing being car racing, perhaps occasional death should come as an expectation. But it never does, not once you get to know the person behind the wheel.

Nguyen Cao Ky

Many who are part of the saga of the Vietnam War are complicated fig-
ures, from the North Vietnamese leader Ho Chi Minh to the American
General William Westmoreland to Lieutenant Oliver North—not to men-
tion Presidents Kennedy, Johnson and Nixon. Nguyen Cao Ky was of the
North, born not far from Hanoi, but led the South in the civil war, first as
commander of the Vietnam Air Force and then as prime minister of South
Vietnam. He was cunning, and during the 1960s negotiated his way
through various coups d'etat and juntas to his leadership posts. He was
vainglorious, disporting in a purple scarf and striding forth with a regal
air. But he was pragmatic; when the end was clear with the fall of Saigon
in 1975 he very readily hopped aboard the USS *Blue Ridge* and fled to
exile in the United States, eventually settling in California, where he ran
a liquor store. He wrote books about the war in his later years, but their
substance, as with much about Ky, was to be taken with a grain of salt.

Madame Nhu

Tran Le Xuan, born in 1924 in Hanoi, was in the late 1950s and earliest '60s the de facto first lady of South Vietnam, and far more influential than either her husband or her bachelor brother-in-law, the president. There was no opinion she held to herself. She hated her country's majority of Buddhists; she dreamed of a military reserve force of 360,000 women (in this picture for LIFE, she takes aim during a session at the Tan Hoa Dong firing range in 1962). She was altogether too hot to handle, and when her husband and brother-in-law were assassinated in a coup in 1963, ostensible allies such as the United States looked the other way. She lived out her long exile in Europe.

Frank Buckles

The passing of this man on February 27 punctuated a passage of time. Frank Buckles, who lived 110 years, was the last surviving American to have served in World War I. He enlisted in the Army in 1917 and fought near the front. Later, he and his wife settled on a farm in West Virginia. His remembrances hearkened to an American mind-set prevalent at the time: "After three years of living and dying inside a dirt trench, you know the Brits and French were happy to see us 'doughboys.' Every last one of us Yanks believed we'd wrap this thing up in a month or two and head back home before harvest. In other words, we were the typical, cocky Americans no one wants around, until they need help winning a war."

Andy Rooney

He was so much more complex and complicated than the dedicated followers of his *60 Minutes* essays ever knew. He was not simply a bushy-browed comedian or a dyed-in-the-wool contrarian; he was a man given to thought. A pacifist when he was drafted into the army in 1941, he flew on bombing raids over Germany and saw the death camps after Europe's liberation. Because of these experiences, he reconsidered his convictions as to whether or not there might be "just wars"—perhaps some of them were valid. Similarly, years later, he laced into the suicide victim Kurt Cobain on *60 Minutes* for wasting a promising life, then apologized the following week after being schooled by his listeners on the sorrows of depression. (He ran only comments that were critical of his essay, with no further opinion.) He told you things you hadn't asked to be told—he washed his hair with the soap bar, not shampoo, because it was quicker and easier—and regularly, Rooney's commentary became Monday morning water-cooler conversation: "Did you here what Andy said about . . . ?" Andy Rooney told you what he thought about just about anything, and he always did so honestly. Rooney, who died at 92 in November, also was honest and energetic enough to know that thoughts he had held only a moment ago might already be changing.

Tim Hetherington

As this year's look at the months recently past comes to its close, we at LIFE find ourselves honoring four who are, given our own history, familiar subjects: two American war veterans in Buckles and Rooney, and now, two intrepid photojournalists in Tim Hetherington and Chris Hondros. Hetherington (above) was born in England in 1970 and was killed in Libya by a mortar shell fired by Muammar Gadhafi's defenses in April when he, Hetherington, was trying to forward the open-ended, perhaps never-ending story of the Arab Spring. After Hetherington graduated from college—not just any college: Oxford University—he traveled on a bequest from his grandmother's will to India, China and Tibet, and during that sojourn decided that he "wanted to make images." He enrolled in night school, he apprenticed himself, he took all the well-trodden steps of LIFE's classic shooters who worked their way up. Then he launched what would become a distinguished career. Hetherington was killed while covering the front lines in the besieged city of Misrata, as was Chris Hondros, whom we will now meet. LIFE has a legacy of photographers fallen in duty—Capa, Burrows, Schutzer—and although Hetherington and Hondros were not officially affiliated with LIFE, we consider them brethren.

Chris Hondros

As said, Hondros died in Libya while covering the same story as Tim Hetherington, who was his associate and friend far more than his rival. They were, to use the cliché, comrades in arms, working the dangerous space that was once worked by Smith, Morse, Silk, Landry, Duncan and Elisofon. Hondros, a native New Yorker, made memorable pictures in his home city on 9/11, and also showed the world what had been happening in Kosovo, Angola, Sierra Leone, Afghanistan, Kashmir, Israel, the West Bank, Iraq . . . Hetherington and Hondros were thoroughly in the tradition of their essential trade—they were exemplars—and, sadly, each paid the ultimate price. We bow to them.

JUST 1 MORE

As we look to 2012, so many of us ask: Can anything bring us together? Well, we in the U.S. can be sure that the election won't. But as a world community, perhaps the Olympic Games will work some good—as they often do. This is an aerial view of London's Olympic Stadium, heralding one year to go. It was completed on March 29 of this year, and will be filled with 80,000 for the opening ceremonies on July 27 of next. Something, indeed, to look forward to. Let the Games begin!